PIANO POWER PLAY SERIES ANIMATION

鋼琴★動畫館

西洋動畫

◇ 18首西洋經典卡通動畫主題音樂，鋼琴獨奏套譜 ◇
◇ 當代最具影響力的動畫片廠及配樂大師介紹 ◇
◇ 內附演唱用歌詞 ◇
◇ 附MP3全曲演奏示範 ◇

演奏示範下載

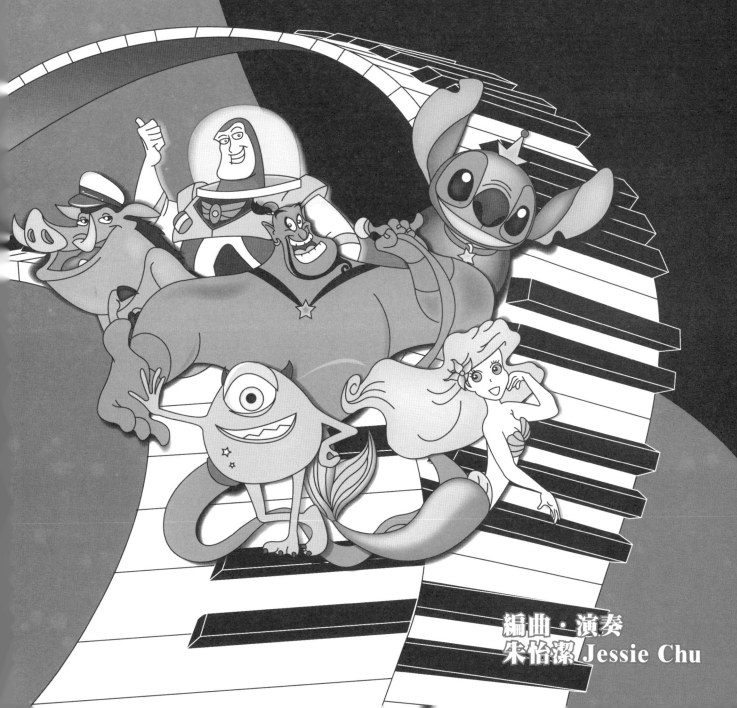

編曲‧演奏
朱怡潔 Jessie Chu

目錄

CONTENTS

1 **A Whole New World**【嶄新的世界 Walt Disney 1992】
阿拉丁【Aladdin】動畫主題曲 -- **10**

2 **Beauty And The Beast**【美女與野獸 Walt Disney 1991】
美女與野獸【Beauty And The Beast】動畫主題曲 ------------------------------- **15**

3 **Can You Feel The Love Tonight**【今夜你能否感覺愛 Walt Disney 1994】
獅子王【The Lion King】動畫主題曲 --- **20**

4 **Can't Help Falling In Love**【無可救藥愛上你 Walt Disney 2002】
星際寶貝【Lilo And Stitch】動畫主題曲 --- **24**

5 **Colors Of The Wind**【風之彩 Walt Disney 1995】
風中奇緣【Pocahontas】動畫主題曲 -- **28**

6 **Go The Distance**【萬水千山 Walt Disney 1997】
大力士【Hercules】動畫主題曲 -- **33**

7 **God Help The Outcasts**【天祐吾民 Walt Disney 1996】
鐘樓怪人【The Hunchback Of Notre Dame】動畫主題曲 ----------------------------- **38**

8 **Once Upon A December**【那一年的十二月 20th Century Fox 1997】
真假公主【Anastasia】動畫主題曲 --- **43**

9 **I Believe I Can Fly**【相信我能飛 Warner Brothers 1996】
怪物奇兵【Space Jam】動畫主題曲 --- **48**

10 **Reflection**【倒影 Walt Disney 1998】
花木蘭【Mulan】動畫主題曲 --- **52**

11 **Shrek Theme**【史瑞克主題曲 DreamWorks SKG 2001】
史瑞克【Shrek】動畫主題曲 --- **56**

12 **Somewhere Out There**【在某處 Universal 1986】
美國鼠譚【An American Tale】動畫主題曲 -- **60**

13 The Prayer【祈禱 Warner Brothers 1998】
魔劍奇兵【Quest For Camelot】動畫主題曲 ----------------- **64**

14 Under The Sea【海底深處 Walt Disney 1989】
小美人魚【The Little Mermaid】動畫主題曲 ----------------- **68**

15 When She Loved Me【當她仍愛我 Walt Disney 1999】
玩具總動員二【Toy Story II】動畫主題曲 ----------------- **72**

16 You'll Be In My Heart【你永在我心 Walt Disney 1999】
泰山【Tarzan】動畫主題曲 ----------------- **76**

17 You've Got A Friend In Me【我是你的好朋友 Walt Disney 1995】
玩具總動員一【Toy Story I】動畫主題曲 ----------------- **80**

18 When You Believe【當你相信 Walt Disney 1999】
埃及王子【Prince Of Egypt】動畫主題曲 ----------------- **84**

曲目索引（按英文字母順序排列）

A Whole New World ...10
Beauty And The Beast ..15
Can You Feel The Love Tonight20
Can't Help Falling In Love24
Colors Of The Wind ..28
Go The Distance ...33
God Help The Outcasts ...38
I Believe I Can Fly ..48
Once Upon A December...43
Reflection ...52
Shrek Theme ...56
Somewhere Out There..60
The Prayer ...64
Under The Sea ...68
When She Loved Me ...72
When You Believe ...84
You'll Be In My Heart ..76
You've Got A Friend In Me......................................80

示範音檔QR Code說明

完整的歌曲演奏示範音檔MP3
至「麥書文化－好康下載」處
下載，共有 3 個壓縮檔。（須加
入麥書文化官網免費會員）

https://bit.ly/2uOMCog

作者序 INTRODUCTION

　　每次看完動畫電影，紅著眼眶走出戲院，一旁的人都驚訝：「你連看卡通也會哭？」他們不知道，當我佇立在佛羅里達的迪士尼「魔幻王國」（Magic Kingdom），注視夜空中綻放的煙火，竟也一個勁兒地抹淚，感動得忘了自己是誰！

　　不同年代的動畫，紀錄了不同時期的心情。小時候，我像白雪公主一樣期待白馬王子來臨，從此過著幸福快樂的日子。如今我長大了，史瑞克的故事讓我明白：華美的外表並非幸福的前提，真愛是在對方面前勇敢做自己。

　　有「亞洲的華特迪士尼」之稱的日本動畫大師宮崎駿（Miyazaki Hayao）認為：創作動畫最重要的靈魂在於對人類的關心，最根本的主題是生命。生命被關心的我們，怎能不被他們的作品撼動？

　　電腦合成技術推陳出新，動畫的精神卻長存——在不用長大的國度裡，每個人都有作夢的權利。儘管現實世界存在著許多問題，至少還能在動畫裡找到一片無邪天地。

　　感謝華特迪士尼，創造了龐大的動畫王國；感謝才華橫溢的電影配樂家，給予觀眾更立體的享受。本書收納了十八首感人的西洋動畫主題曲，也介紹當代最具影響力的動畫片廠及配樂大師，希望帶領讀者更深一層感受動畫之美。

朱怡潔

星座
有點叛逆的獅子座

血型
可以捐給任何人的O型

最愛的一句話
生命就該浪費在美好的事物上

最欣賞的音樂人
久石讓、Secret Garden、Ennio Morricone

著作
鋼琴動畫館（日本、西洋）
超級星光樂譜集
交響情人夢鋼琴演奏特搜全集
愛星光精選──昨天今天明天
Hit 101《中文流行鋼琴百大首選》
經典電影主題曲30選
iTouch《就是愛彈琴》鋼琴雜誌
婚禮主題曲30選

推薦序 INTRODUCTION

跟Jessie（怡潔的英文名字）認識，其實是趁工作之便，沒什麼太正式的相遇。那時我負責加拿大東部山葉鋼琴的業務，必須常與代理商往來。就在一次訪談中，認識了剛上工不久的Jessie，對她留下了深刻而奇妙的印象。她有幾分羞怯，卻充滿了好奇，微笑的眼睛令人感覺親切，但話並不多。

一個月後，重返那間代理商，聽見店裡一陣悅耳琴聲。走近一看，原來是Jessie在演奏。當時的她全神貫注，心裡只有音樂。我沒聽過那首曲子，卻被她柔和的觸鍵深深打動，只盼她繼續彈下去。那一刻，我完全將工作拋諸腦後，開始忘情地和她一起彈琴、談論音樂、交換彼此的想法。之後兩年內，我們常一起沉浸在這種樂趣中，對我而言是極寶貴的經驗。很高興能找到一位知己，用自然不造作的方式切磋音樂。

可惜好景不常，她決定回台灣定居，我也因工作要求，搬到了另一個國家。兩年沒跟Jessie見面，仍無法忘懷她扣人心弦的琴音。希望她在臺灣過得開心，在音樂世界裡找到自己的一片天。她總在探索音樂的靈魂，也為多倫多的教會作曲編曲。但願回到台灣的她，能很快找到一群志同道合的朋友，分享她最愛的音樂。由衷祝福她！

史坦‧契爾林斯基（Stan Zielinski）檔案：

現任：山葉鋼琴北美區藝術公關總監

曾任：加拿大CBC廣播電台音樂製作人
　　　加拿大蕭邦鋼琴大賽主席委員
　　　渥太華卡爾頓大學爵士音樂講師
　　　波蘭Komedia Musical Theater演奏、作曲及指揮

學歷：波蘭華沙蕭邦音樂學院首席鋼琴碩士

曲目解說
SONG TECHNIQUES

❶ A Whole New World【嶄新的世界 Walt Disney 1992】
阿拉丁【Aladdin】動畫主題曲

副歌中右手二聲部有自己的表情，但不應蓋過主旋律；左手和弦要穩重清晰。三連音節奏須平均。57小節開始的尾奏，希望營造出一問一答的效果，直到63小節第三拍始融合為一。小心不要越彈越快。

❷ Beauty And The Beast【美女與野獸 Walt Disney 1991】
美女與野獸【Beauty And The Beast】動畫主題曲

原曲是由音色晶瑩清亮的電鋼琴伴奏。改編成鋼琴獨奏曲後，仍希望沿用該效果。注意音色的亮度和飽滿度。和聲部分要整齊。有些和弦（如第一小節）乃由左右手合力完成，須有一體成形的感覺。「Beauty and the Beast（Mi-Fa-Re-Mi-Do）」的主題頻頻出現，若當作裝飾樂句，則不應蓋過主旋律。

❸ Can You Feel The Love Tonight【今夜你能否感覺愛 Walt Disney 1994】
獅子王【The Lion King】動畫主題曲

和弦須飽滿結實，營造出莊嚴寬闊的氣勢。由於速度不快，十六分音符應避免趕拍子或混淆不清。18~19、26~27及30~31小節的低音是級進音階，每個音都要確實表現。

❹ Can't Help Falling In Love【無可救藥愛上你 Walt Disney 2002】
星際寶貝【Lilo And Stitch】動畫主題曲

曲子不長，看似簡單，表達起來卻有相當難度。左手三連音須平均，控制音量，不應蓋過右手旋律。每小節和弦根音要明顯，裝飾音輕輕帶過即可。右手和弦避免太強，予人突兀之感。可略加些彈性速度。

❺ Colors Of The Wind【風之彩 Walt Disney 1995】
風中奇緣【Pocahontas】動畫主題曲

較長的曲子。30小節之前都不用太快，但表情要豐富，彷彿有人在耳畔低迴。31~34小節間奏結束後速度增加，曲風轉為明朗活潑，有如原野上恣意奔馳。強弱及速度變化仍須清晰，營造出曲子的高潮。

❻ Go The Distance【萬水千山 Walt Disney 1997】
大力士【Hercules】動畫主題曲

右手有許多十六分音符，注意速度的穩定，不要忽快忽慢，且仍須有表情。左右手交替出現旋律，角色變化要清楚。低沉的部分要穩重，象徵堅定的決心；高昂的部分則要有「雖千萬人吾往矣」的壯闊氣勢。強弱的對比是關鍵。

❼ God Help The Outcasts【天祐吾民 Walt Disney 1996】
鐘樓怪人【The Hunchback Of Notre Dame】動畫主題曲

原曲在電影中，是一篇會讓人感動流淚的禱文。演奏時應盡量表現出歌曲中的殷殷企盼，用心處理每個樂句，使其細膩且情緒豐沛。左手第二小節第二拍的二和弦由一根拇指同時彈出，分解和弦須有表情。較長的樂句要一氣呵成，強調圓滑度。

❽ Once Upon A December【那一年的十二月 20th Century Fox 1997】
真假公主【Anastasia】動畫主題曲

19~20、27~28、37、59~60、67~68、77、92~93、100~101小節中，左手音程跨幅大，難度較高。細心經營第一、二段副歌中右手的二聲部。此曲需要較多練習，升降記號也相對複雜，因此於本書中難度評比居首。

❾ I Believe I Can Fly【相信我能飛 Warner Brothers 1996】
怪物奇兵【Space Jam】動畫主題曲

速度較慢，須維持穩定，表情盡量豐富。左手低音看似平淡無奇，其實不乏發揮空間，可製造出低音吉他（bass guitar）般的效果。留意八分音符和十六分音符之間的轉換。

10 Reflection【倒影 Walt Disney 1998】
花木蘭【Mulan】動畫主題曲

39小節開始，右手上方旋律及底下裝飾音的對比要明顯；43小節手掌逐漸上移，須維持樂句的延續性，避免出現空隙。漸強與漸弱要忠實呈現。33及58小節的右手皆有旋律尾音與伴奏重疊的情況，兩者須並重，讓聽眾能清楚分辨。

11 Shrek Theme【史瑞克主題曲 DreamWorks SKG 2001】
史瑞克【Shrek】動畫主題曲

雖是小調，仍須表現出三拍子的輕巧。曲子不長，但每個樂句都脆弱纖細，一不小心就會破壞整首曲子的美感。左手和弦一開始便有相當難度，三度音要整齊，且營造出波動感。非旋律的裝飾音不要太強。

12 Somewhere Out There【在某處 Universal 1986】
美國鼠譚【An American Tale】動畫主題曲

耳熟能詳的溫馨曲調。以溫柔低沉的旋律作為開頭，在每個段落加諸不同的情緒，使曲子具有不斷延伸的張力。副歌可謂曲子的高潮，而55小節又須比34小節更為激昂。左手有幾個分解和弦跨的幅度較廣，避免彈錯並留心強弱。

13 The Prayer【祈禱 Warner Brothers 1998】
魔劍奇兵【Quest For Camelot】動畫主題曲

此曲極為抒情，且速度甚慢，情感處理上須費點功夫，以免曲子變得庸俗粗糙。右手有較多八度音程，上下音量須協調；彈奏時除使用大拇指和小指，盡量加入一、四指的組合，可提高手的靈活度。旋律與裝飾的樂句有一搭一唱的效果，但裝飾句不應壓過旋律。

14 Under The Sea【海底深處 Walt Disney 1989】
小美人魚【The Little Mermaid】動畫主題曲

熱鬧活潑而又不失旋律性的可愛樂曲，從頭到尾都很有精神，無須使用踏瓣。曲子裡有大量切分音和連結線，需要相當的節奏感。右手多為二部和聲，旋律須明顯。左手低音要渾圓飽滿，每小節第一拍根音清楚。

15 When She Loved Me【當她仍愛我 Walt Disney 1999】
玩具總動員二【Toy Story II】動畫主題曲

本曲演奏時採用即興速度（ad lib），有較大的表達空間。前奏、間奏和尾奏中左右手平行的部分，音量須協調，營造出搖籃曲般的流暢；小心該處的踏瓣—換不乾淨會混沌一片，換得太多則會顯得支離破碎。

16 You'll Be In My Heart【你永在我心 Walt Disney 1999】
泰山【Tarzan】動畫主題曲

此版本採自電影中較柔和的配樂，而非Phil Collins的Pop編曲。難度不高，但須表達出真摯的情感，如催眠曲般從容且溫暖。1~8小節左手和弦要整齊並注意音量，襯托右手由單音構成的旋律。掌握副歌中右手二聲部的旋律，可豐富曲子的內涵。

17 You've Got A Friend In Me【我是你的好朋友 Walt Disney 1995】
玩具總動員一【Toy Story I】動畫主題曲

輕鬆活潑卻又帶點慵懶的爵士風曲調，不須踩踏瓣。在無踏瓣的情況下維持樂句完整，有一定的難度—哪個音拍子沒彈夠，一聽就能聽出來，因此每一拍都應按足，觸鍵要深入。節奏清晰，避免趕拍子。雖未使用圓滑線，但1~5小節的旋律其實是個完整的大樂句，強弱變化須有整體感。

18 When You Believe【當你相信 Walt Disney 1999】
埃及王子【Prince Of Egypt】動畫主題曲

本曲算是書中較長的一首。第一頁至第二頁中點出主題，反覆時副歌轉調，段落間須營造出層次感。副歌的主要樂句和裝飾句對比要明顯。第二頁開始一段風格強烈的間奏，注意樂句完整及強弱變化，42小節的音階彈均勻。轉A大調的副歌是曲子的高潮，處理強音（f）時手臂放鬆，反能締造更大音量。

動畫廠介紹
ANIMATED FACTORY INTRODUCE

迪士尼 DISNEY

◆ It's kind of fun to do the impossible（Walt Disney）
挑戰不可能的事亂有意思的。－華特・迪士尼

1901年，華特迪士尼在伊利諾州的芝加哥出生。音樂天才莫札特六歲開始旅行演奏；具有藝術天分的華特，則是七歲開始向鄰居兜售畫作。

人們公推華特迪士尼為動畫始祖。二十三歲那年，他憑著四處募集的八百美元，在加州好萊塢創立他的動畫事業。最原始的工作室是親戚的車庫。五年後，迪士尼王國當家台柱米老鼠（Mickey Mouse）誕生，於1928年擔綱主演「威利蒸汽船」（Steamboat Willie），是人類史上首部配音卡通。

1937年，美國經濟跌到谷底，迪士尼卻耗資一千五百萬製作了「白雪公主」（Snow White and Seven Dwarfs），是電影史上第一部擁有完整電影長度的動畫。接下來五年陸續完成「木偶奇遇記」（Pinocchio）、「幻想曲」（Fantasia）、「小飛象」（Dumbo）和「小鹿班比」（Bambi）。

1971年，迪士尼世界（Disney World）在佛羅里達州（Florida）正式開幕，至今已開放四個主題公園：充滿童話情懷的夢幻王國（Magic Kingdom）、展示現代科技的愛普卡中心（EPCOT Center）、介紹電影製作過程的MGM攝影棚（MGM Studio）以及營造出叢林氣氛的動物王國（Animal Kingdom）。

1991年五月，迪士尼與皮克斯（Pixar）公司合作，以更炫的科技推出畫質精美的作品。「玩具總動員」（Toy Story）、「蟲蟲危機」（A Bug's Life）、「怪獸電力公司」（Monsters, Inc.）、「海底總動員」（Finding Nemo）以及「超人特攻隊」（The Incredibles），都是他們的心血結晶。

最近，迪士尼也買下日本動畫大師宮崎駿（Hayao Miyazaki）卡通的翻譯版權，讓更多觀眾得窺亞洲動畫之美。華特迪士尼相信：對一個勇於築夢的人來說，沒有解決不了的難題。每個人都有作夢的權利，更有圓夢的潛力。最重要的，是永遠保持一顆赤子之心！

華納兄弟　WARNER BROS. ENTERTAINMENT

　　顧名思義，華納兄弟製片廠是由華納家四兄弟聯合創立，誕生於1923年。事實上早在二十年前，四人便已開始他們的電影生涯，帶影片四處巡迴演出。1927年，華納兄弟推出有史以來第一部配音電影「爵士歌唱家」（The Jazz Singers）。

　　擁有近百年歷史，華納製作了無數經典電影。從電影系學生必修的「北非諜影」（Casablanca）、陪我們長大的「超人」（Superman）到大帥哥布萊德彼特主演的「特洛伊」（Troy）和風靡全球的「哈利波特」（Harry Potter），可謂族繁不及備載。

　　動畫方面，大家耳熟能詳的有：吃了菠菜肌肉會鼓起來的「大力水手」（Popeye）、永遠追不上飛毛腿老鼠的壞貓（Tom & Jerry），還有動不動就說「Hey，doc!」的灰色頑皮兔（Bugs Bunny）。不久前上演的「狗狗震」（Scooby-Doo），也是華納的代表作。

夢工場　DREAMWORKS SKG

　　夢工場製片公司成立於1994年十月，主要成員包括大導演史蒂芬・史匹柏（Steven Spielberg）、製片家傑佛瑞・卡贊柏（Jeffrey Katzenberg）以及企業鉅子大衛・蓋芬（David Geffen）。秉持大夥兒追夢的熱情，加上三人姓氏的頭一個字母，合稱DreamWorks SKG。

　　雖是相對年輕的片廠，卻一鼓作氣推出一連串強檔動畫，包括1998年改編自聖經故事的「埃及王子」（Prince of Egypt）、2001年的「史瑞克」（Shrek）和2004年以強大配音陣容為號召的「鯊魚黑幫」（Shark Tale）。每部作品皆引起廣大迴響。其中「史瑞克」更榮獲奧斯卡年度最佳動畫的殊榮。

　　夢工場的經營理念，是藉著電影、電視節目和音樂，將歡笑散播給全世界的觀眾。

A Whole New World —— 嶄新的世界

【阿拉丁】主題曲　Aladdin

◆ 作曲：Alan Menken

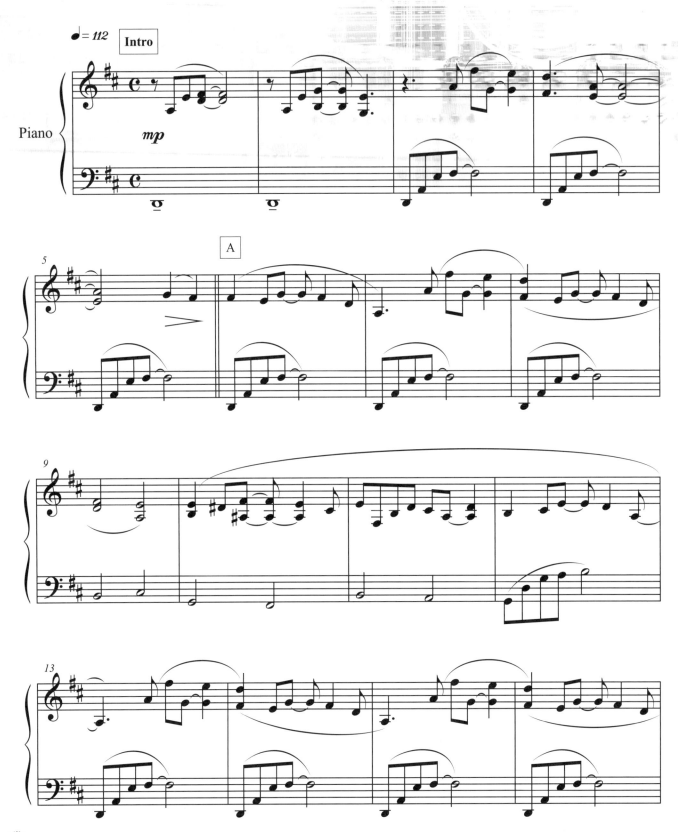

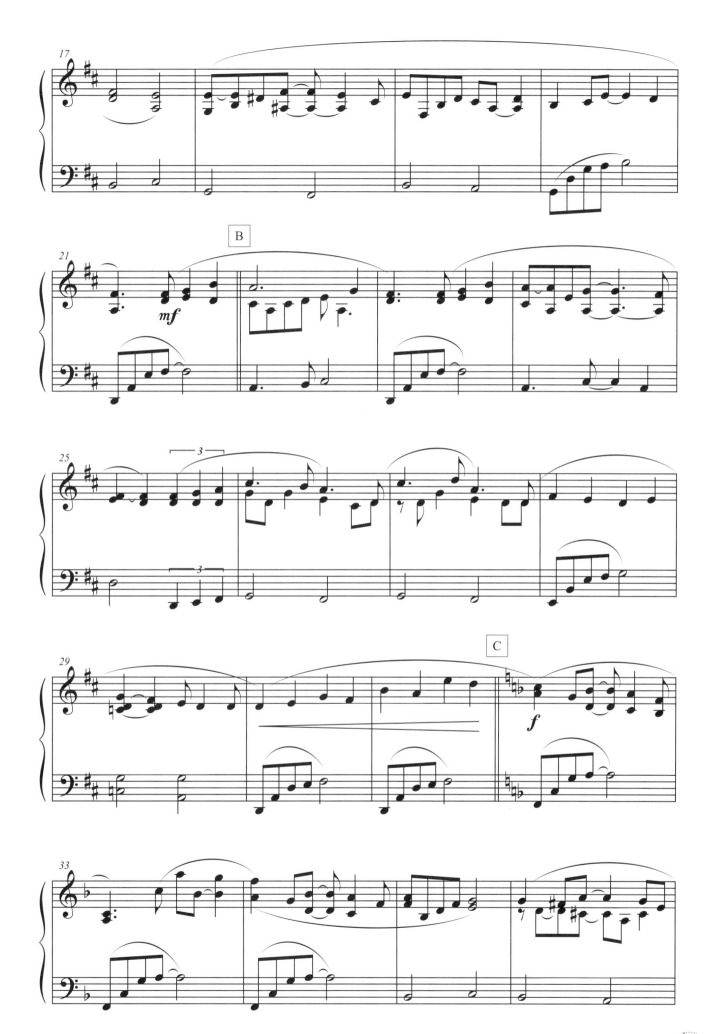

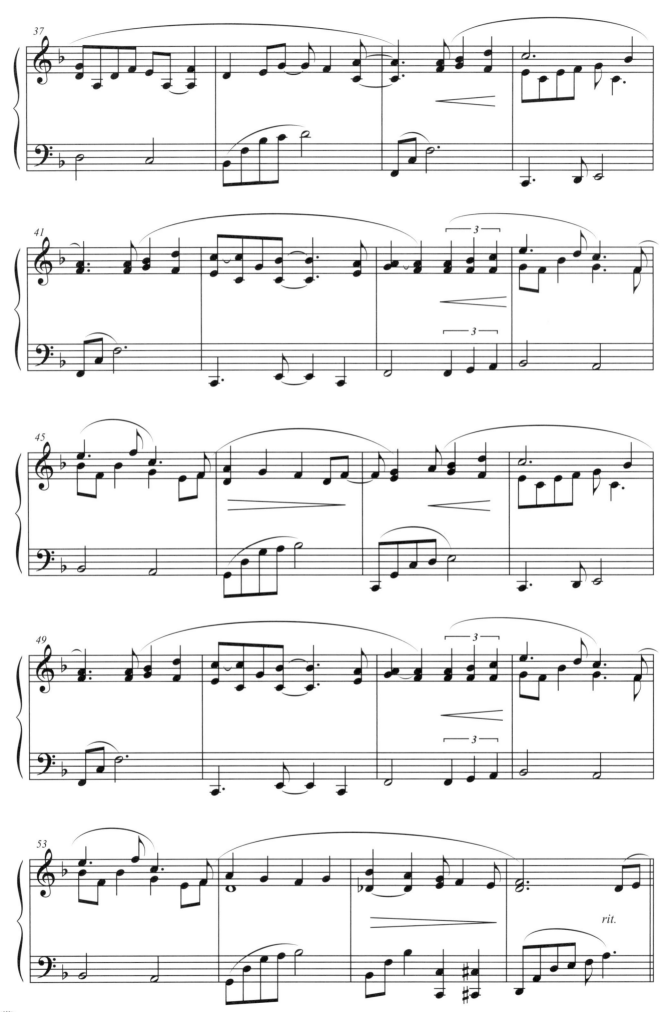

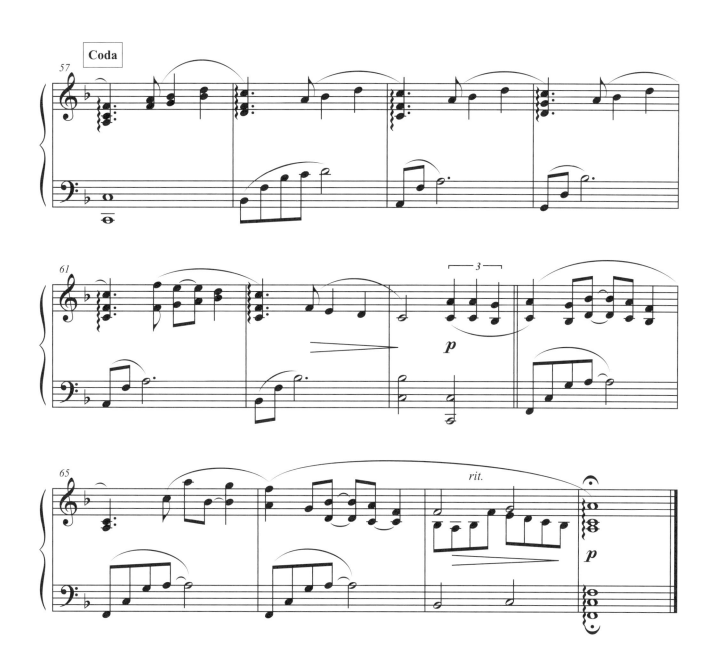

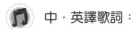 中‧英譯歌詞： **A Whole New World** 嶄新的世界

(A) I can show you the world	我要帶你去一個閃亮的新世界
Shining, shimmering, splendid	公主啊 請告訴我
Tell me, princess, now when did	你的心曾在何處停泊
You last let your heart decide?	我將開啟你的雙眼
I can open your eyes	帶你經歷一切神奇
Take you wonder by wonder	乘著魔毯
Over sideways and under	天上地下盡情探索
On a magic carpet ride	嶄新的世界
A whole new world	嶄新而夢幻的視野
A new fantastic point of view	沒人能阻擋
No one to tell us no	或限制我們的方向
Or where to go	或批評我們只是空想
Or say we're only dreaming	
	嶄新的世界
(J) A whole new world	我不曾見識的炫麗奪目
A dazzling place I never knew	身在其中
But when I'm way up here	感覺如此真切
It's crystal clear	與你一同奔向嶄新的世界
That now I'm in a whole new world with you	我們來到嶄新的世界
(A) Now I'm in a whole new world with you	
	不可思議的景象
(J) Unbelievable sights	難以言喻的感動
Indescribable feeling	無邊無際的天空裡
Soaring, tumbling, freewheeling	我們自由飛翔
Through an endless diamond sky	嶄新的世界
A whole new world	別閉上你的眼睛
(A) Don't you dare close your eyes	太多值得發掘的事物
(J) A hundred thousand things to see	請你屏息以待
(A) Hold your breath - it gets better	我成了一顆流星
(J) I'm like a shooting star	經過遙遠的旅程
I've come so far	再不願回到從前
I can't go back to where I used to be	嶄新的世界
(A) A whole new world	每次回頭都有驚喜
(J) Every turn a surprise	一片嶄新的天地
(A) With new horizons to pursue	時刻充滿變化
(J) Every moment gets better	我們有充裕的時間
(A&J) I'll chase them anywhere	盡情追逐
There's time to spare	讓我與你分享這嶄新的世界
Let me share this whole new world with you	嶄新的世界
(A) A whole new world	是我們的終點
(J) A whole new world	那兒令人驚喜
(A) That's where we'll be	那兒如此美好
(J) That's where we'll be	屬於我和你
(A) A thrilling chase	
(J) A wondrous place	
(A&J) For you and me	

註：A：Aladdin　J：Jasmine

Beauty And The Beast — 美女與野獸

【美女與野獸】主題曲　Beauty And The Beast

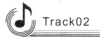

◆ 作曲：Alan Menken

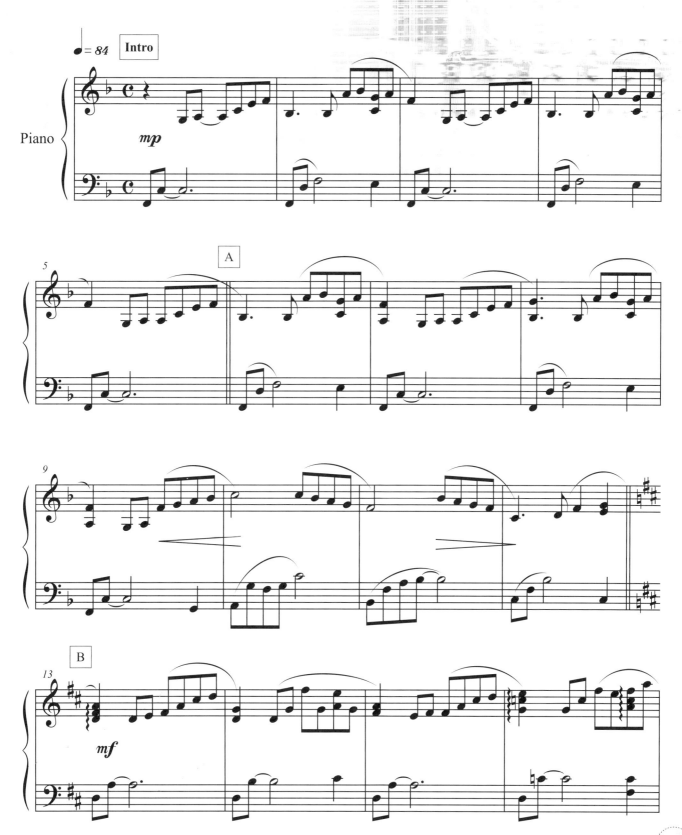

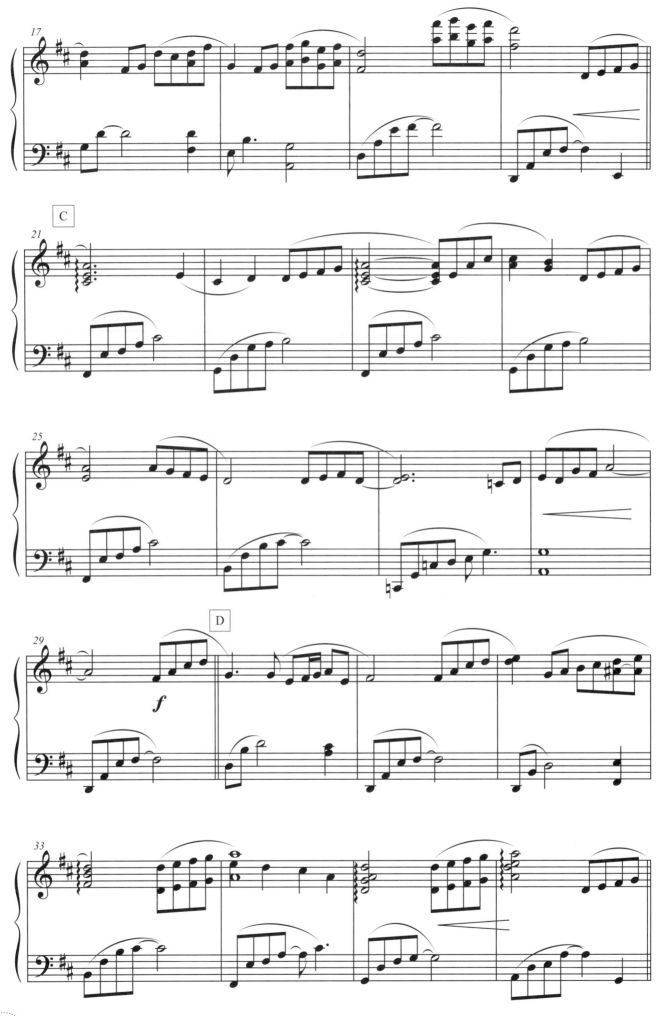

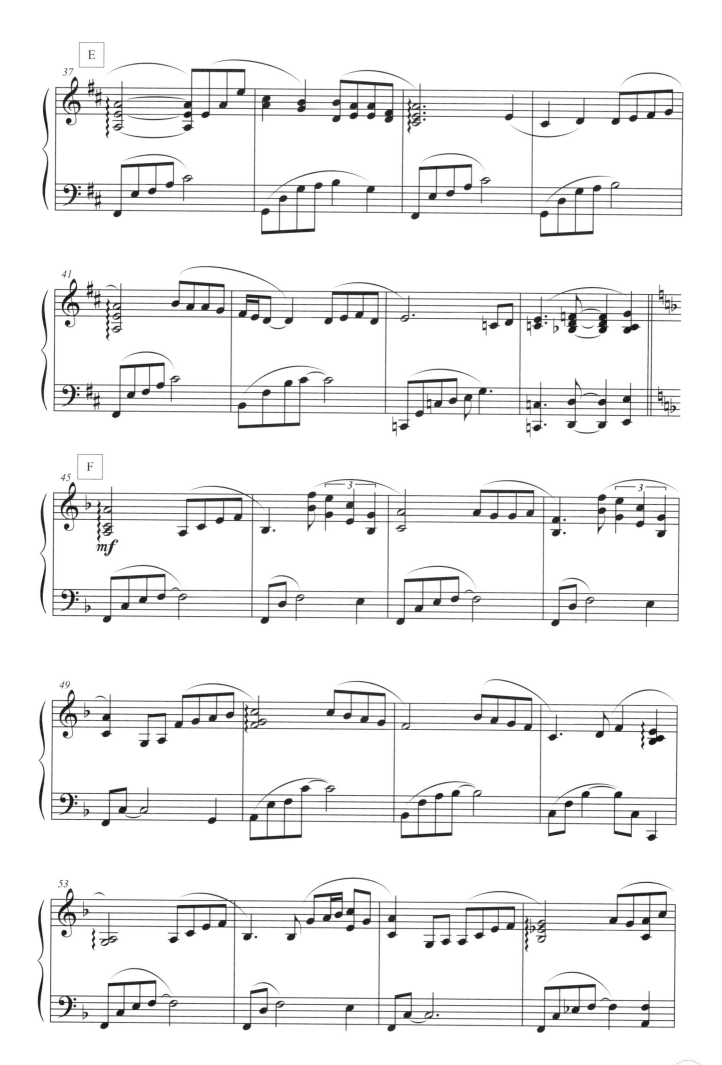

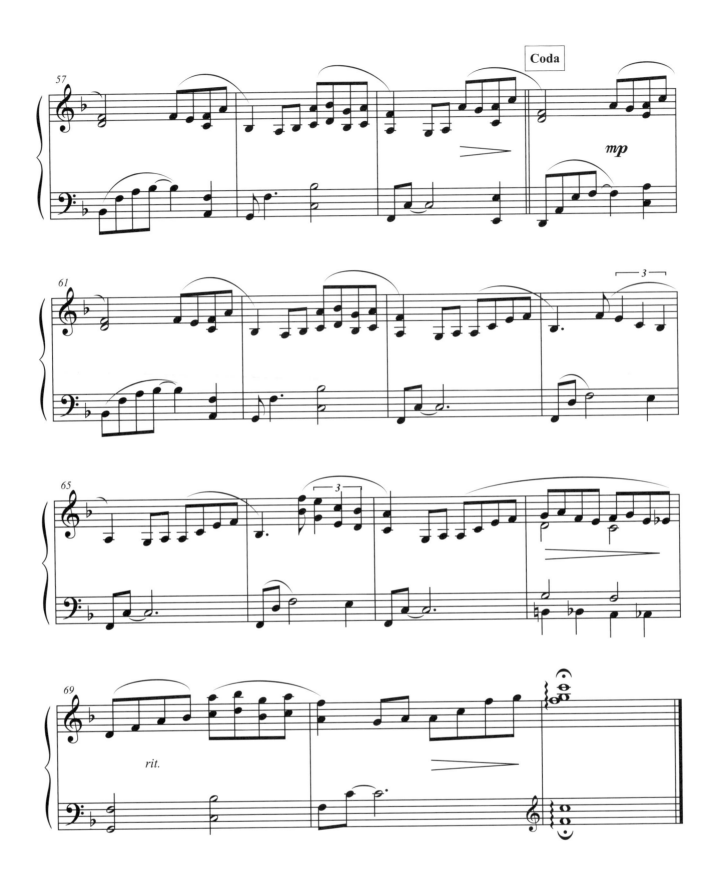

Beauty And The Beast 美女與野獸

Tale as old as time	亙古長存的故事
True as it can be	如此真實
Barely even friends	原本素不相識的兩人
Then somebody bends	意外地
Unexpectedly	起了變化
Just a little change	只有一點點不同
Small to say the least	幾乎微不足道
Both a little scared	兩人都戰戰兢兢
Neither one prepared	沒有心理準備
Beauty and the Beast	他們是美女與野獸
Ever just the same	永遠存在
Ever a surprise	充滿驚奇
Ever as before	始終如一
Ever just as sure	堅定相信
As the sun will rise	如同太陽定然升起
Tale as old as time	亙古長存的故事
Tune as old as song	像一首優美的歌
Bitter sweet and strange	有苦有甜 有些陌生
Finding you can change	你已學會
Learning you were wrong	從過去的錯誤中改變
Certain as the sun（certain as the sun）	日出東方般
Rising in the east	不變的真理
Tale as old as time	像時間般古老的故事
Song as old as rhyme	像詩韻般悠揚
Beauty and the Beast	美女與野獸
Tale as old as time	亙古長存的故事
Song as old as rhyme	像詩韻般悠揚
Beauty and the beast	美女與野獸

Can You Feel The Love Tonight　　今夜你能否感覺愛

【獅子王】主題曲　The Lion King

◆ 作曲：Elton John

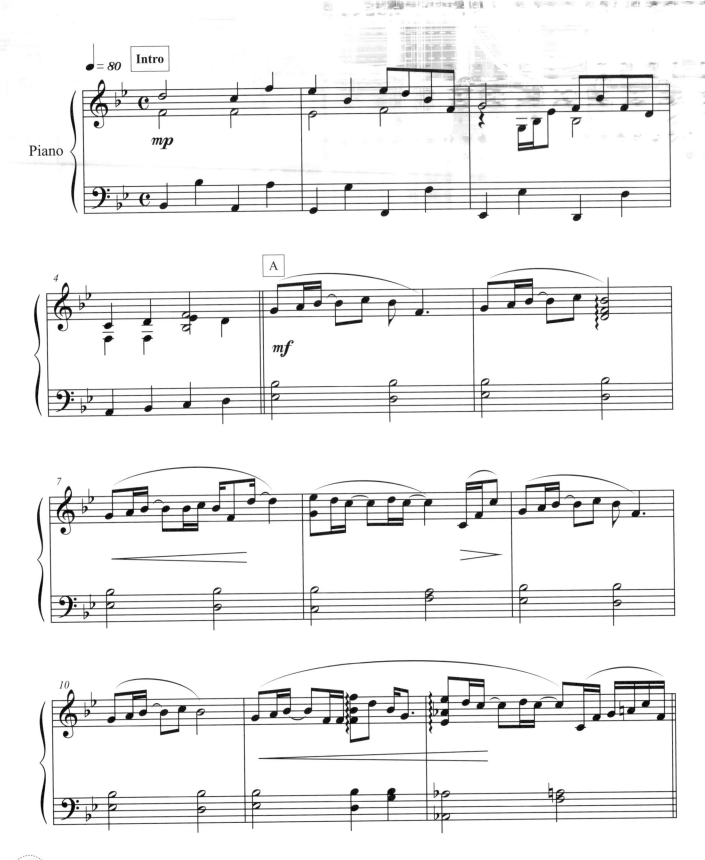

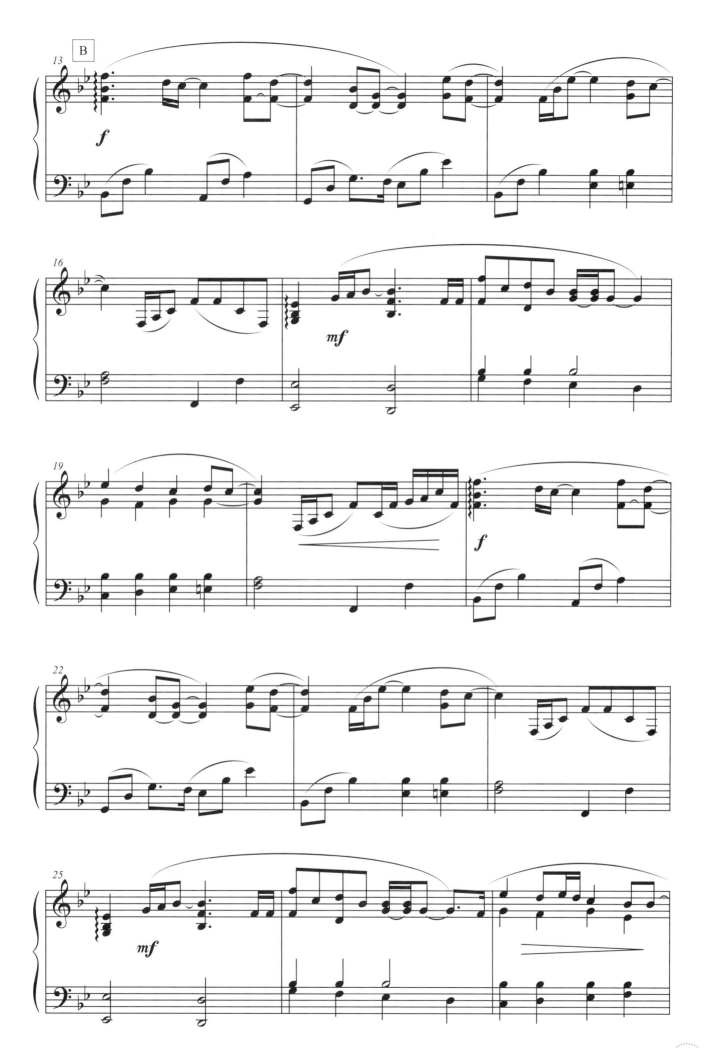

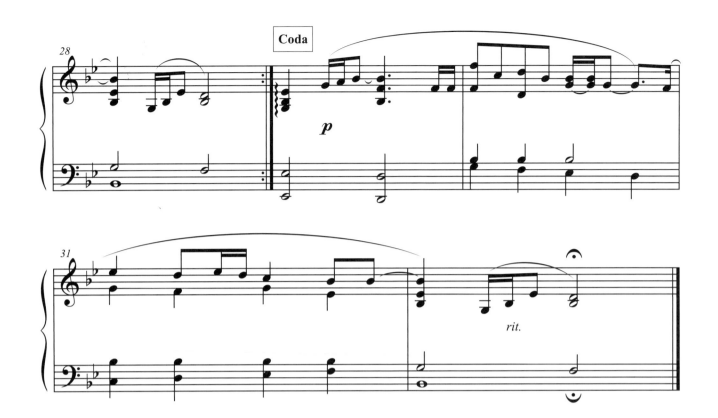

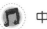
There's a calm surrender to the rush of day	忙碌的日子終於沉靜
When the heat of the rolling world	沸騰轉動的世界
Can be turned away	也得以冷卻
An enchanted moment	夢幻的時刻
And it sees me through	我放下自己
It's enough for this restless warrior just to be with you	疲累的戰士渴望與你共享寧靜
And can you feel the love tonight	今夜你能否感覺愛
It is where we are	就在我們身邊
It's enough for this wide-eyed wanderer	流浪過天涯海角
That we got this far	該暫歇片刻了
And can you feel the love tonight	今夜你能否感覺愛
How it's laid to rest	它是如此安祥
It's enough to make kings and vagabonds	無論地位尊卑
Believe the very best	都擁有相同的信念
There's a time for everyone if they only learn	每個人都該知道
That the twisting kaleidoscope moves us all in turn	我們在世界的萬花筒裡輪流轉動
There's a rhyme and reason to the wild outdoors	當我們的心以相同的節奏跳動
When the heart of this star-crossed voyager	我們將理解
Beats in time with yours	宇宙萬物其實是個常數
And can you feel the love tonight	今夜你能否感覺愛
It is where we are	就在我們身邊
It's enough for this wide-eyed wanderer	流浪過天涯海角
That we got this far	該暫歇片刻了
And can you feel the love tonight	今夜你能否感覺愛
How it's laid to rest	它是如此安祥
It's enough to make kings and vagabonds	無論地位尊卑
Believe the very best	都擁有相同的信念

Can't Help Falling In Love 無可救藥愛上你

【星際寶貝】主題曲 Lilo And Stitch

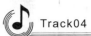

◆ 作曲：George Weiss, Hugo Peretti & Luigi Creatore

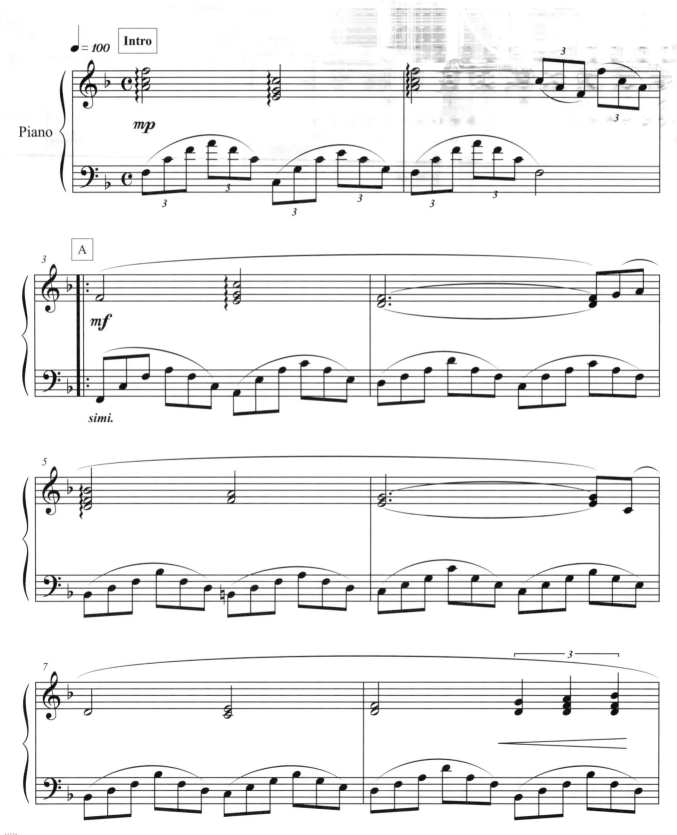

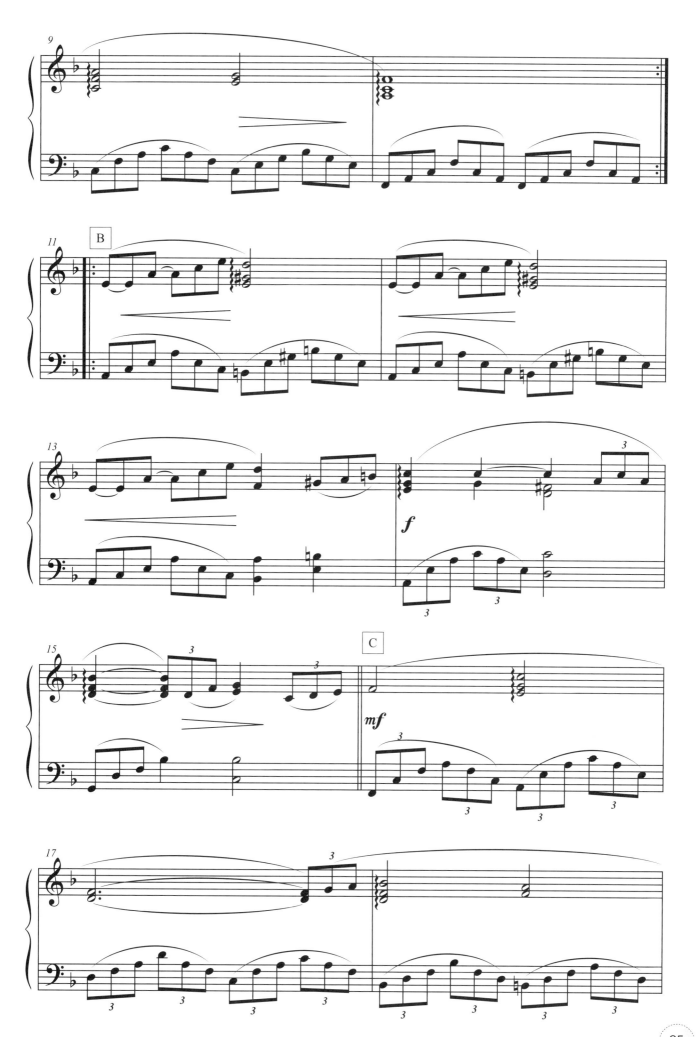

25

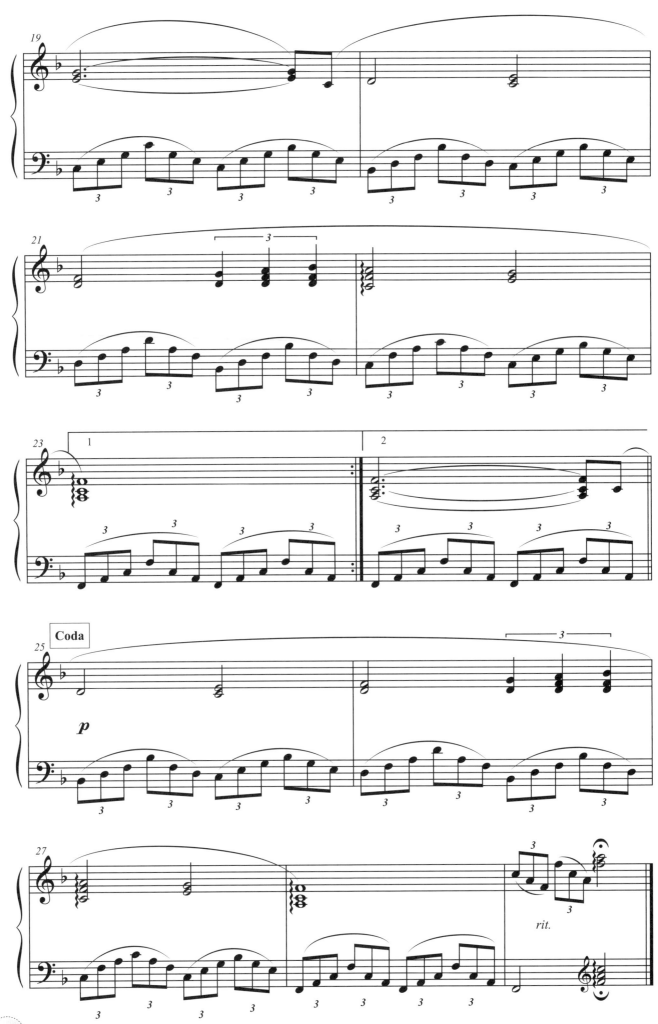

 中 · 英譯歌詞： **Can't Help Falling In Love** 無可救藥愛上你

Wise men say
Only fools rush in
But I can't help falling in love with you

Shall I stay
Would it be a sin
If I can't help falling in love with you

Like a river flows surely to the sea
Darling so it goes
Some things are meant to be

Take my hand
Take my whole life too
For I can't help falling in love with you

聰明人說
傻瓜才會墜入愛河
我卻情不自禁愛上了你

該繼續嗎
情不自禁愛上你
是不是一種罪

如同江河必定流入大海
親愛的
有些事是命中註定

牽我的手
許我一個未來
因我已情不自禁愛上你

Colors Of The Wind — 風之彩

【風中奇緣】主題曲　**Pocahontas**

◆ 作曲：Alan Menken

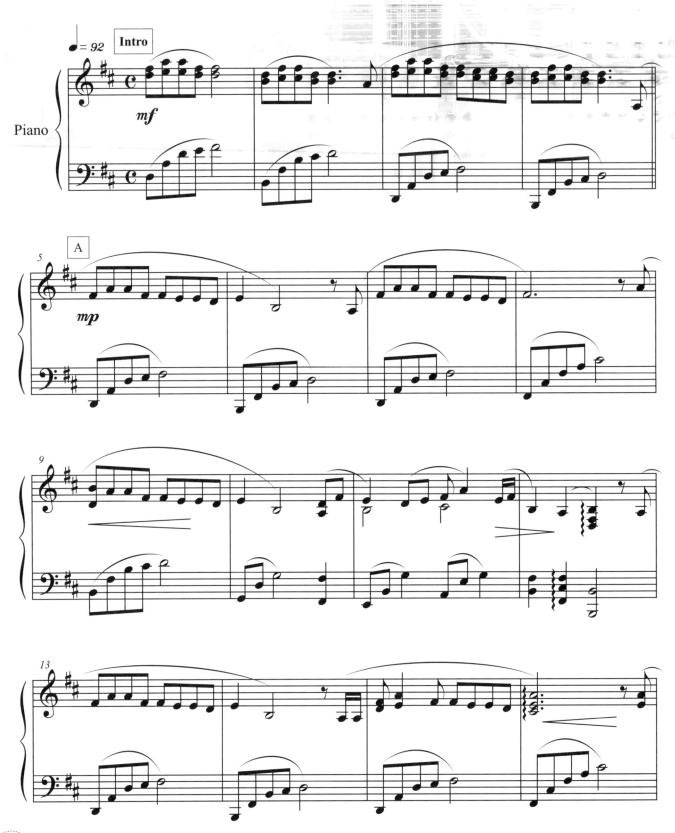

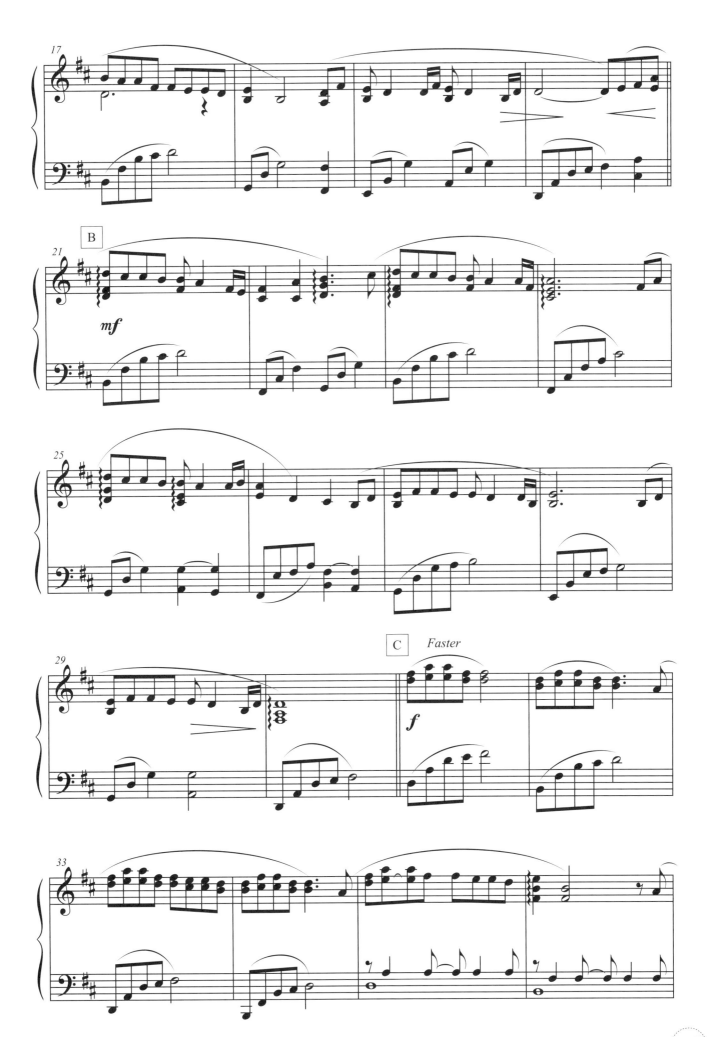

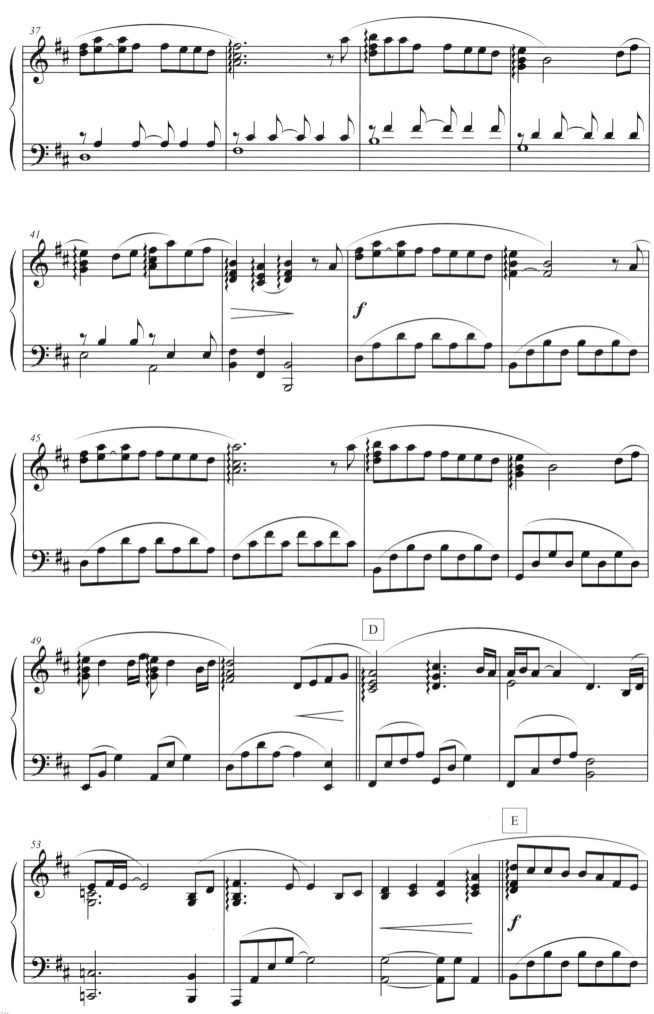

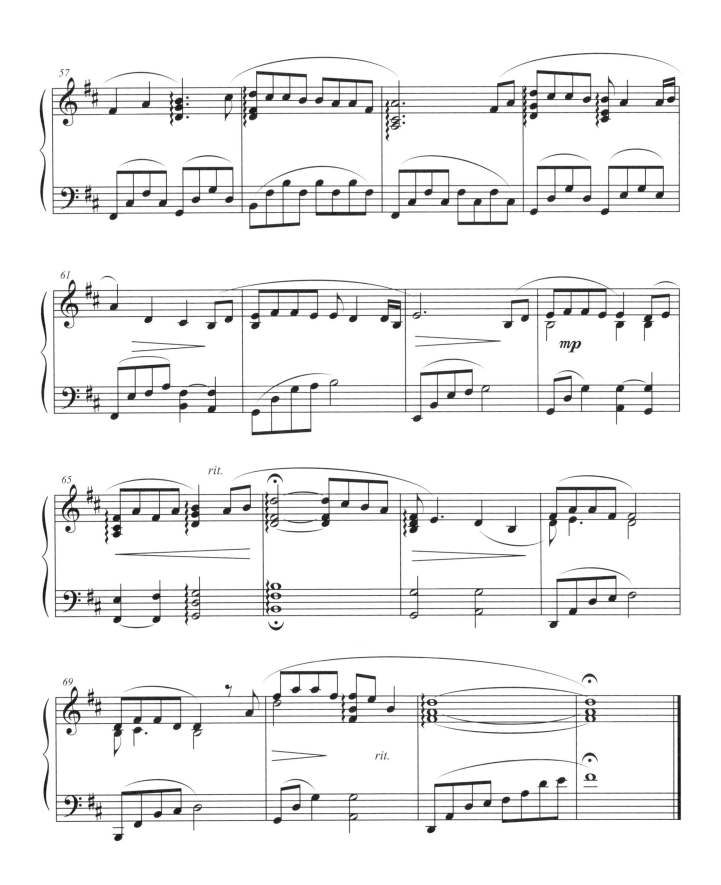

You think I'm an ignorant savage
And you've been so many places
I guess it must be so
But still I cannot see
If the savage one is me
How can there be so much that you don't know
You don't know

You think you own whatever land you land on
The earth is just a dead thing you can claim
But I know every rock and tree and creature
Has a life, has a spirit, has a name

You think the only people who are people
Are the people who look and think like you
But if you walk the footsteps of a stranger
You'll learn things, you never knew, you never knew

Have you ever heard the wolf cry to blue corn moon
Or asked the grinning bobcat why he grinned
Can you sing with all the voices of the mountain
Can you paint with all the colors of the wind
Can you paint with all the colors of the wind

Come, run the hidden pine trails of the forest
Come, taste the sun sweet berries of the earth
Come roll in all the riches all around you
And for once never wonder what they're worth

The rainstorm and the river are my brothers
The heron and the otter are my friends
And we are all connected to each other
In a circle in a hook that never ends

How high does the sycamore grow
If you cut it down
Then you'll never know
And you'll never hear the wolf cry to the blue corn moon
For whether we are white or copper skinned
We need to sing with all the voices of the mountain
We have to paint with all the colors of the wind
You can own the earth and still
All you'll own is earth
Until you can paint with all the colors of the wind

你認為我是無知的野蠻人
我想你一定遊覽過許多地方
但我不明白
倘若無知的人是我
為何還會有那麼多
你不知道的事

你認為你踏上的土地都屬於你
大地不過是無生命的資產
但我熟悉每塊石頭、每顆樹、每種生物
它們有生命 有靈魂 甚至有名字

你認同的族群
是長得像你、動作像你的人
但你若追溯陌生人的足跡
將會發現許多新奇的事物

你可曾聽過月光下的狼嚎
和咆哮的山貓
你能否聽見山谷的迴響
你能否畫出風的顏色
你能否畫出風的顏色

奔馳在森林裡的松樹大道
品嘗陽光下的鮮甜野莓
發掘身邊的豐富資產
別考慮它們值多少錢

暴風雨跟河流與我情同手足
老鷹和水獺是我的朋友
彷彿一個大家庭
永遠緊緊相繫

棕樹能長多高
如果將它砍倒
就永遠不會知道
你將再也聽不見月光下的狼嚎
無論你來自何方
我們要和山谷同唱
畫出風的顏色
你可以擁有土地
卻感受不到它的生命
除非有一天
你能畫出風的顏色

Go The Distance 萬水千山

【大力士】主題曲　Hercules

◆ 作曲：Alan Menken

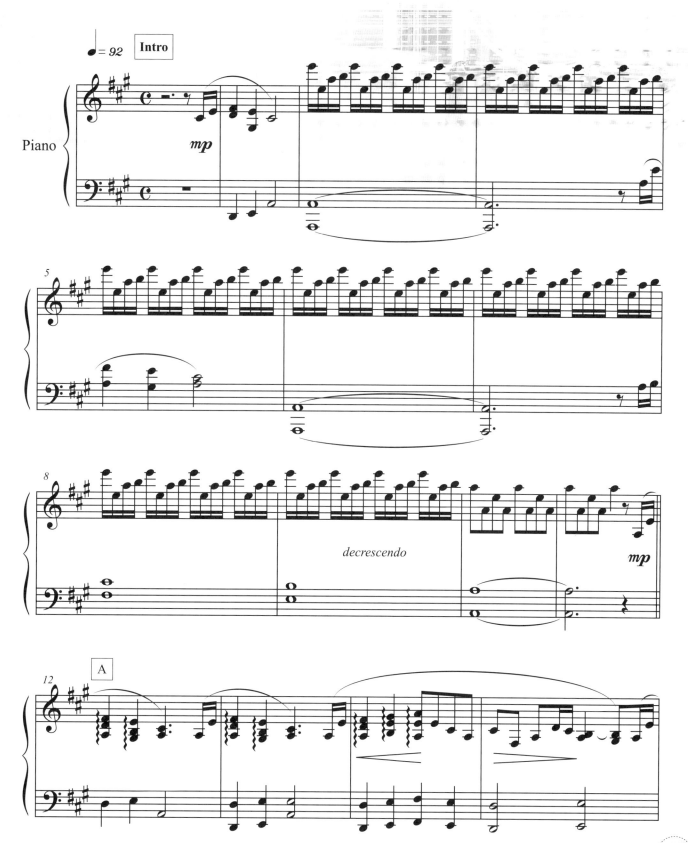

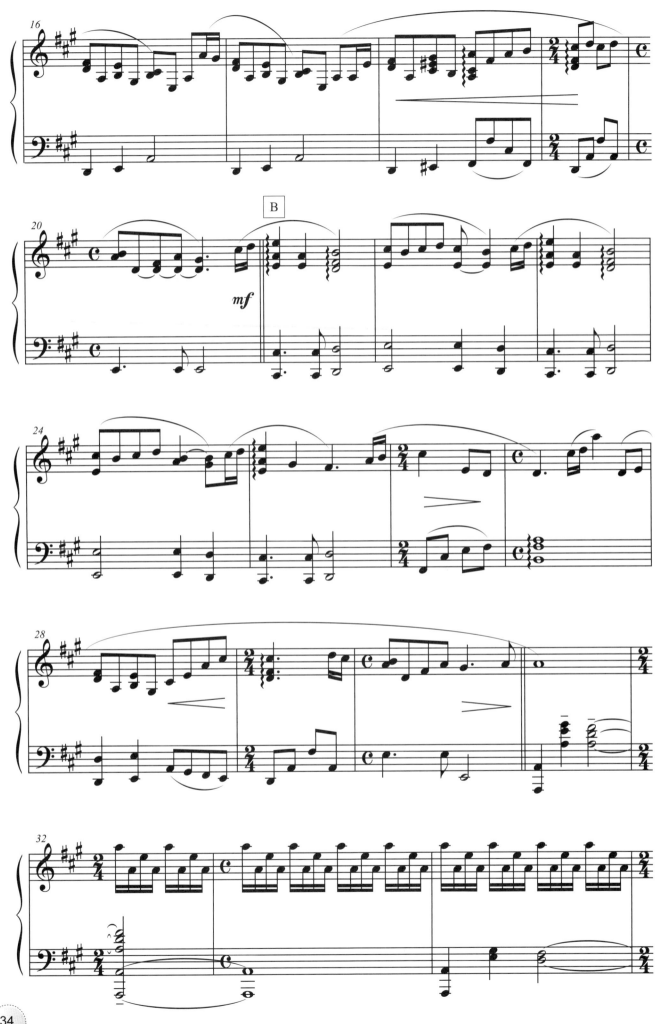

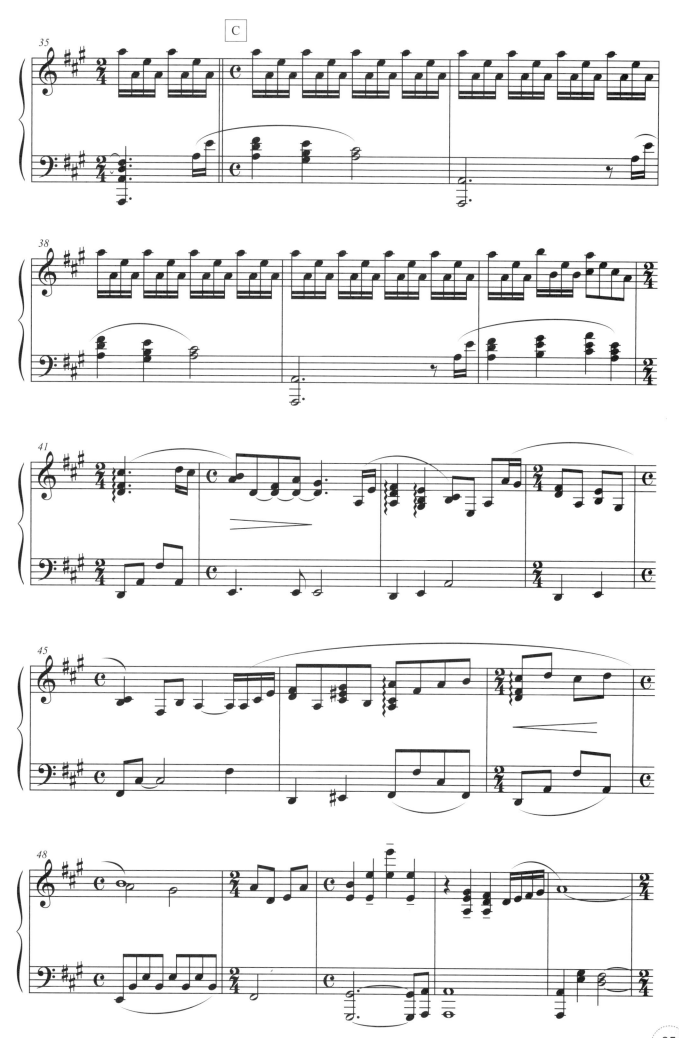

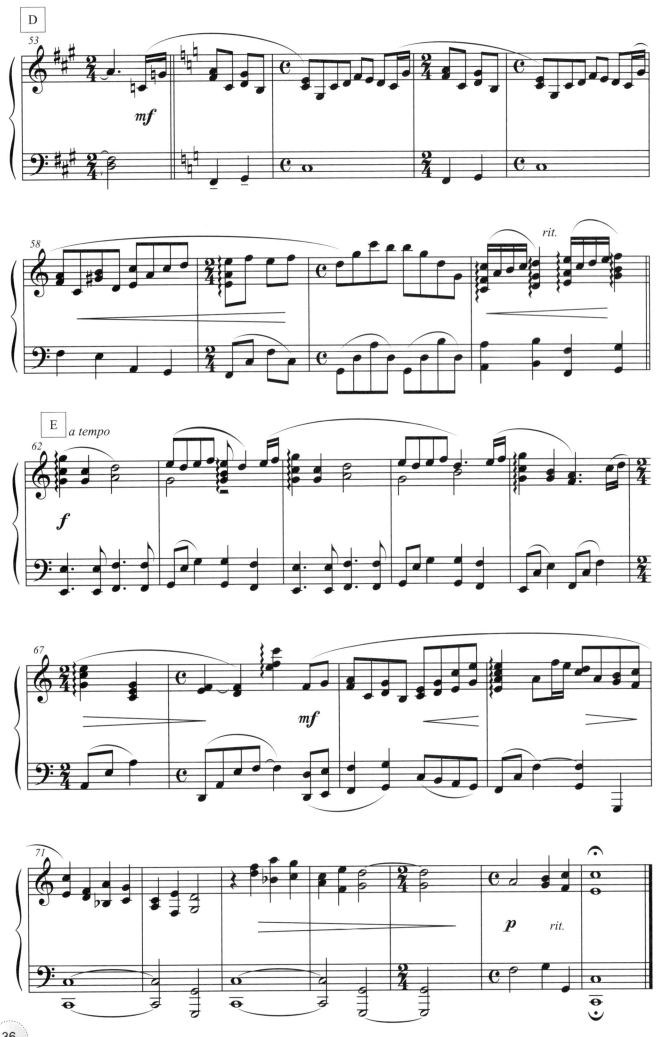

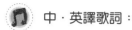

Go The Distance 萬水千山


I have often dreamed of a far off place	我常夢見 一個遙遠的國度
Where a hero's welcome	人們熱情地歡迎我
Would be waiting for me	把我看做英雄
Where the crowds will cheer	群眾歡喜雀躍
When they see my face	是為了我的出現
And a voice keeps saying	有聲音告訴我
This is where I'm meant to be	那是屬於我的地方
I'll be there someday	有一天我會到達
I can go the distance	無懼萬水千山
I will find my way, if I can be strong	只要堅持 我會走出自己的路
I know every mile will be worth my while	踏出每一步都有意義
When I go the distance	跨過萬水千山
I'll be right where I belong	我會找到自己的國度
Down an unknown road to embrace my fate	走在陌生的道路 我跟隨命運的指引
Though that road may wander	縱然前途茫茫
It will lead me to you	終究會找到你
And a thousand years	千年的等待
Would be worth the wait	也是值得
It may take a lifetime	我不惜付上一生的代價
But somehow I'll see it through	因我已預見終點的美好
And I won't look back	我不會回頭
I can go the distance	無懼萬水千山
And I'll stay on track	我持續前進
No I won't accept defeat	決不輕言放棄
It's an uphill slope, but I won't lose hope	坡路再陡 也不失去希望
Till I go the distance	直到我跨越萬水千山
And my journey is complete	完成這段旅程
But to look beyond the glory	目光放遠 不因眼前的榮耀自滿
Is the hardest part	是最大的挑戰
For a hero's strength is measured by his heart	成為英雄 必須先戰勝自己的心
Like a shooting star, I can go the distance	如流星劃過天際 我將越過萬水千山
I will search the world; I will face its harms	探索世界 面對一切困難
I don't care how far; I can go the distance	不管路有多遠 我要越過萬水千山
Till I find my hero's welcome	直到投入你的雙臂
Waiting in your arms	成為你的英雄

God Help The Outcasts 天祐吾民

【鐘樓怪人】主題曲　The Hunchback of Notre Dame

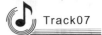

◆ 作曲：Alan Menken

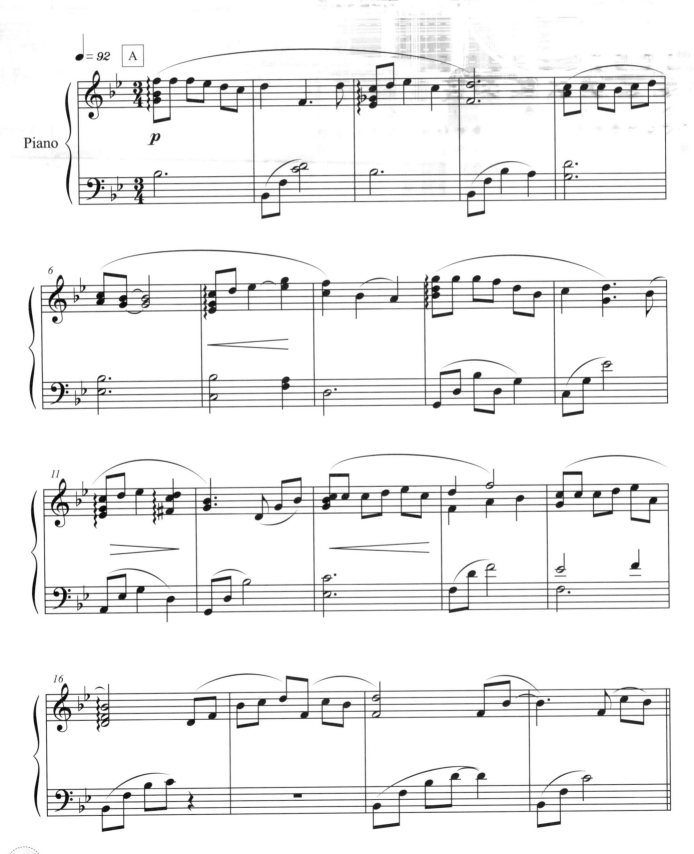

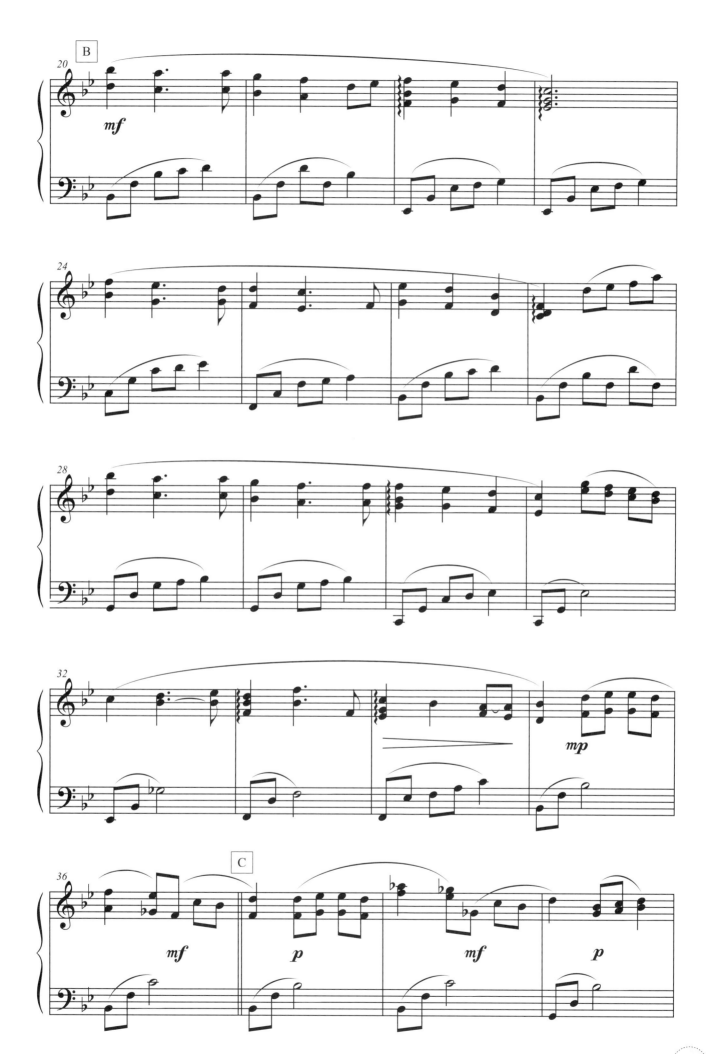

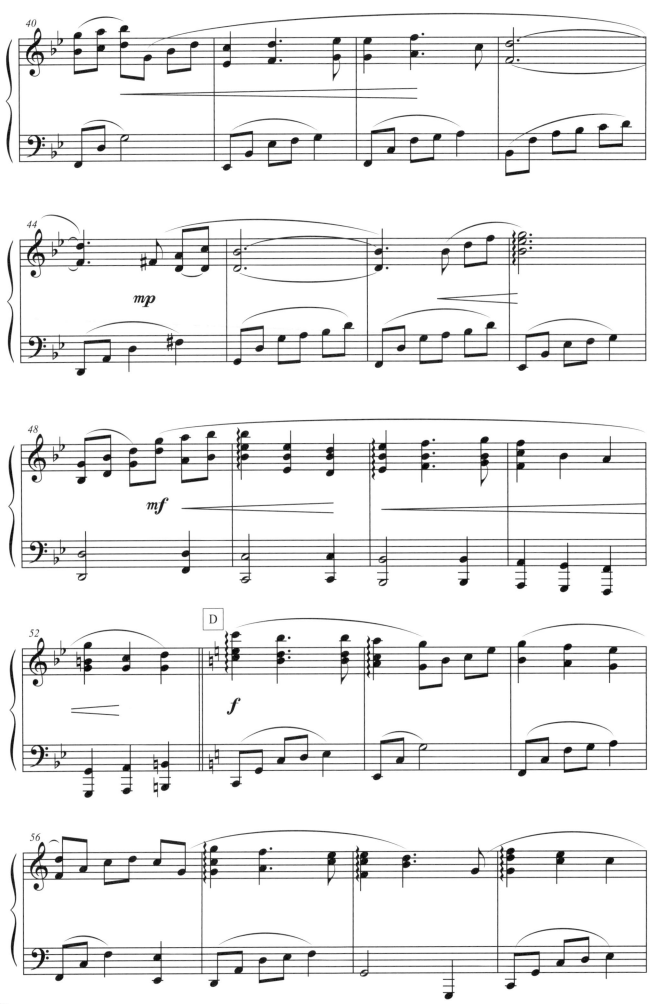

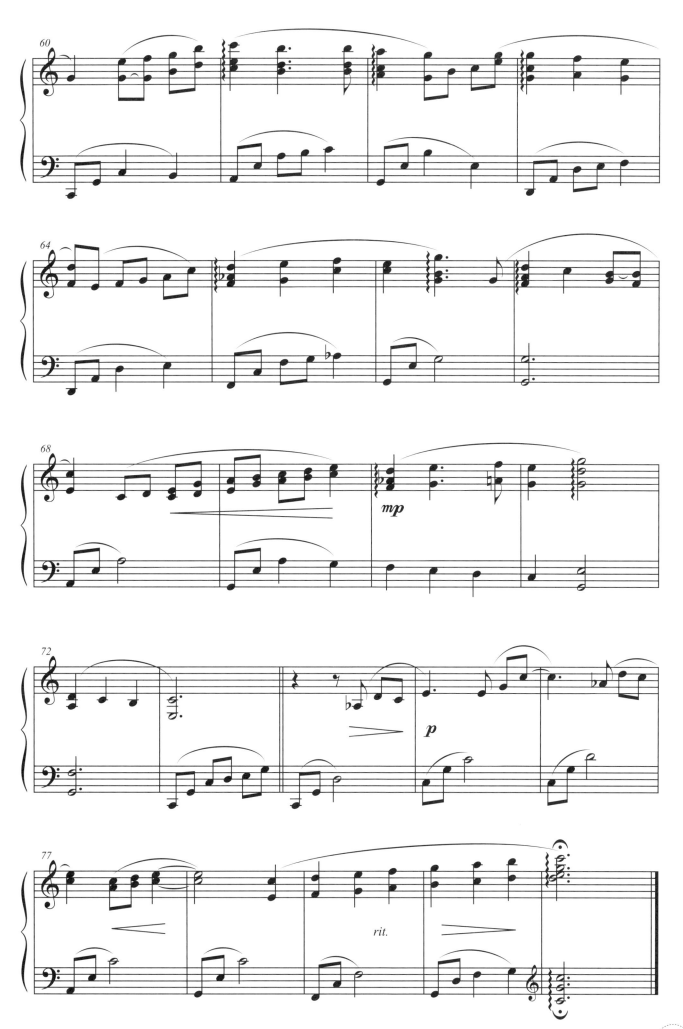

（Esmeralda）
I don't know if You can hear me
Or if You're even there
I don't know if You would listen
To a gypsy's prayer
Yes, I know I'm just an outcast
I shouldn't speak to you
Still I see Your face
And wonder
Were You once an outcast too

God help the outcasts
Hungry from birth
Show them the mercy
They don't find on earth
God help my people
We look to You still
God help the outcasts
Or nobody will

（Parishioners）
I ask for wealth
I ask for fame
I ask for glory to shine on my name
I ask for love I can possess
I ask for God and His angels to bless me

（Esmeralda）
I ask for nothing
I can get by
But I know so many
Less lucky than I
Please help my people
The poor and down-trod
I thought we all were the children of God
God help the outcasts
Children of God

（愛默蕊妲）
不知你能否聽見
不知你是否存在
不知你願不願意聆聽
一個吉普塞人的禱告
我知道自己是外邦人
不該向你祈求
然而我凝望你的臉
忍不住想問
你是否也嘗過被放逐的滋味

神啊 幫助我的人民
他們窮得三餐不繼
向他們彰顯
人間沒有的憐憫
神啊 幫助我的人民
我們也都仰望你
神啊 除了你
再沒有人願意給予同情

（沉淪的世人）
我要財富
我要名聲
我要世間的榮耀
我想擁有一切的愛
我要上帝和天使的祝福

（愛默蕊妲）
我什麼都不要
我擁有的已足夠
但我知道有太多人
比我更不幸
求你保守我的人民
他們在貧困和苦難中掙扎
我相信我們都是神的兒女
神啊 幫助我們
我們是你的兒女

Once Upon A December　那一年的十二月

【真假公主】主題曲　**Anastasia**

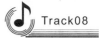

◆ 作曲：Stephen Flaherty

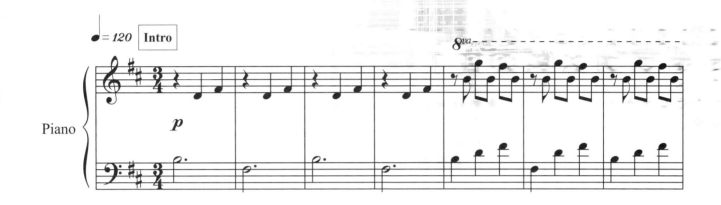

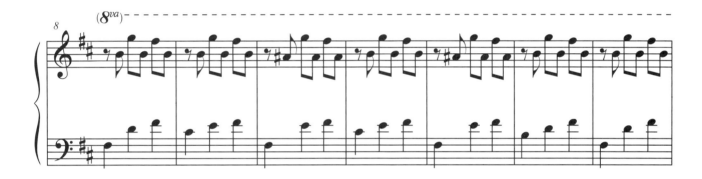

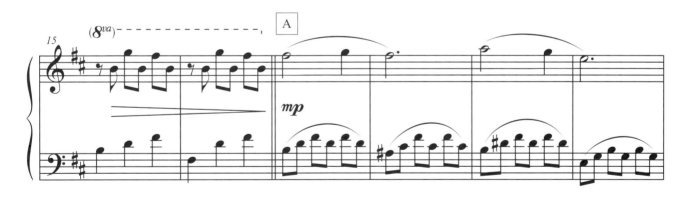

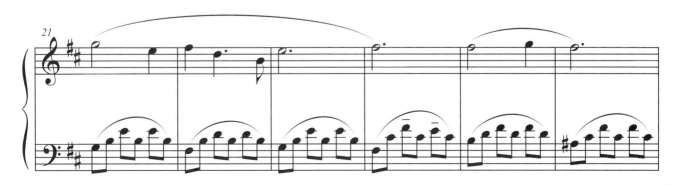

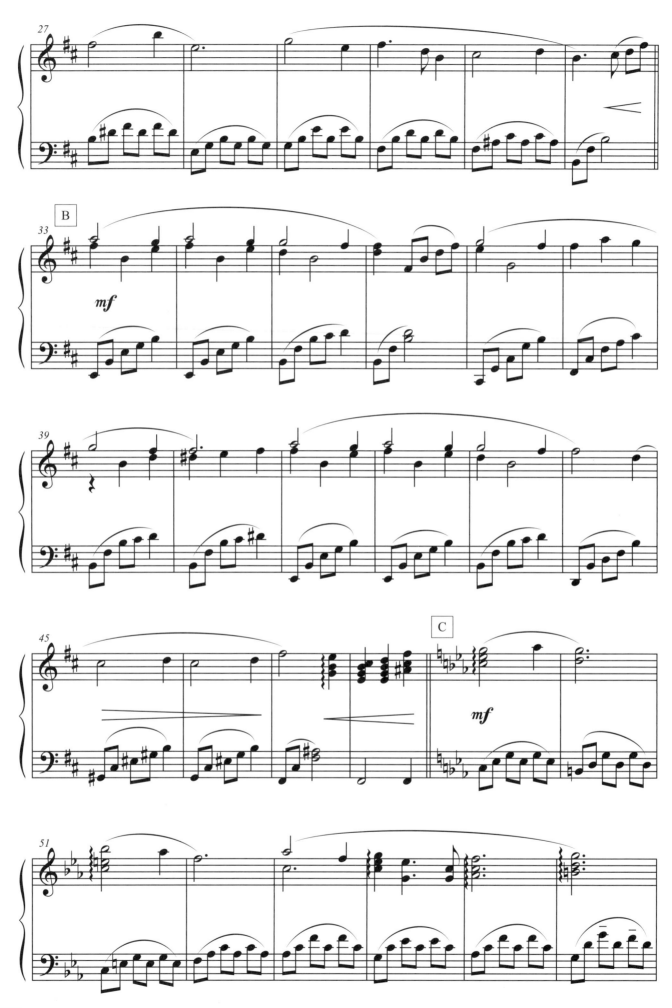

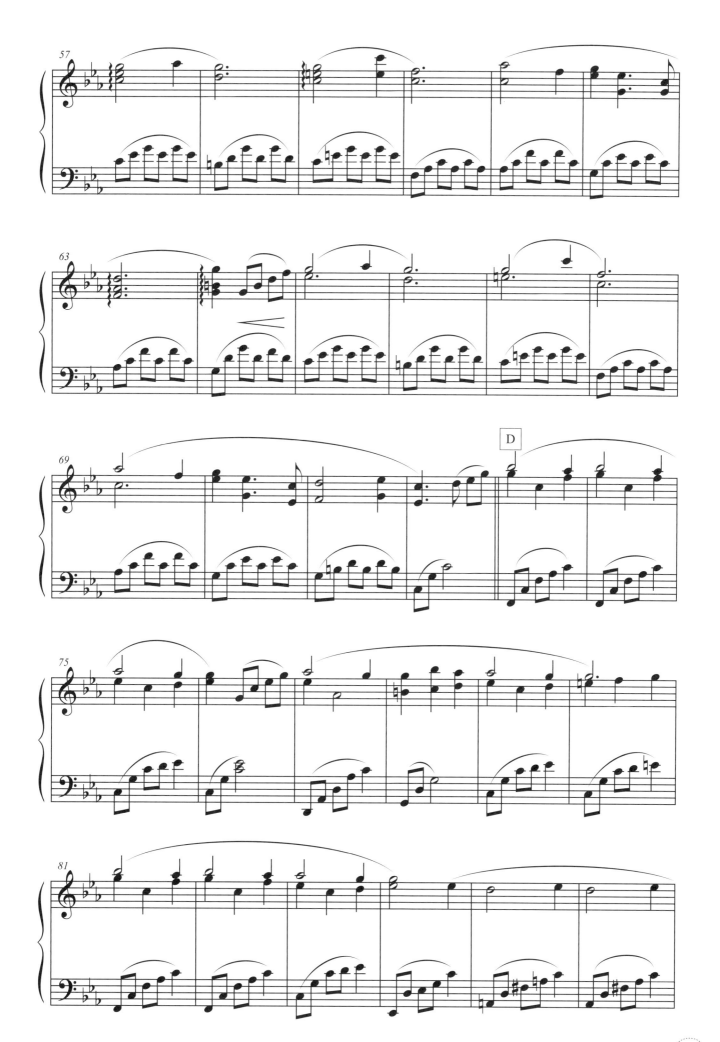

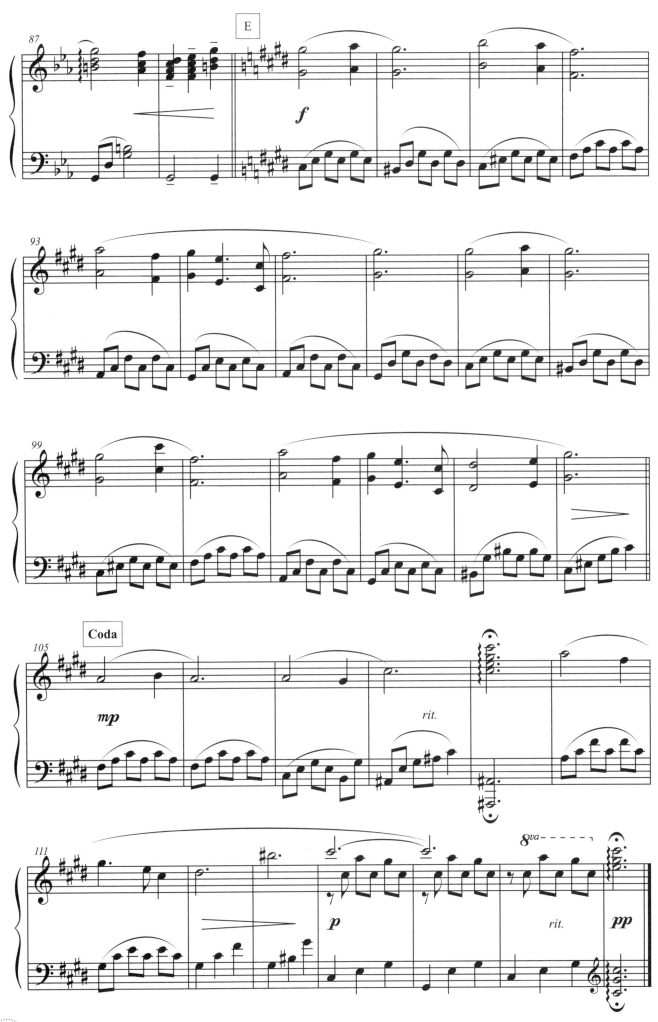

Dancing bears
Painted wings
Things I almost remember
And a song someone sings
Once upon a December

Someone holds me
Safe and warm
Horses prance through a silver storm
Figures dancing gracefully
Across my memory

Far away
Long ago
Glowing dim as an ember
Things my heart used to know
Once upon a December

Someone holds me
Safe and warm
Horses prance through a silver storm
Figures dancing gracefully
Across my memory

Far away
Long ago
Glowing dim as an ember
Things my heart used to know
Things it yearns to remember
And a song someone sings
Once upon a December

跳舞的熊
五彩的羽翼
我能記起的一切
和某人唱的歌
都在那一年的十二月

有人抱著我
安全又溫暖
銀白雪光中有小馬跳躍
人們優雅的舞蹈
存在我的記憶

在很遠的地方
很久很久以前
熠熠星火閃爍
我曾熟知的一切
都在那一年的十二月

有人抱著我
安全又溫暖
銀白雪光中有小馬跳躍
人們優雅的舞蹈
存在我的記憶

在很遠的地方
很久很久以前
熠熠星火閃爍
我曾熟知的
我迫切想要記起的一切
還有某人唱的歌
都在那一年的十二月

I Believe I Can Fly 相信我能飛

【怪物奇兵】主題曲　Space Jam

◆ 作曲：R. Kelly

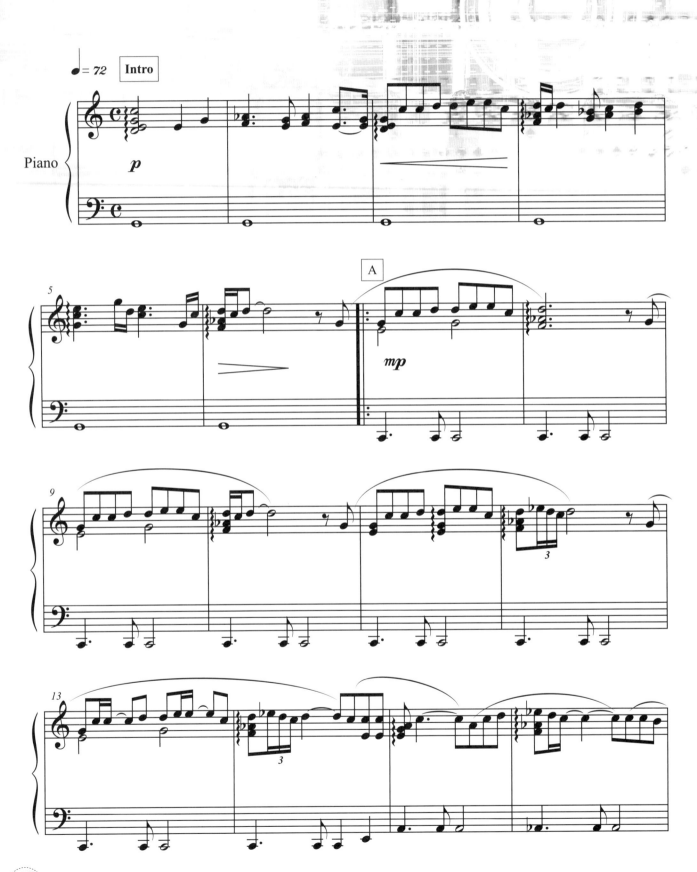

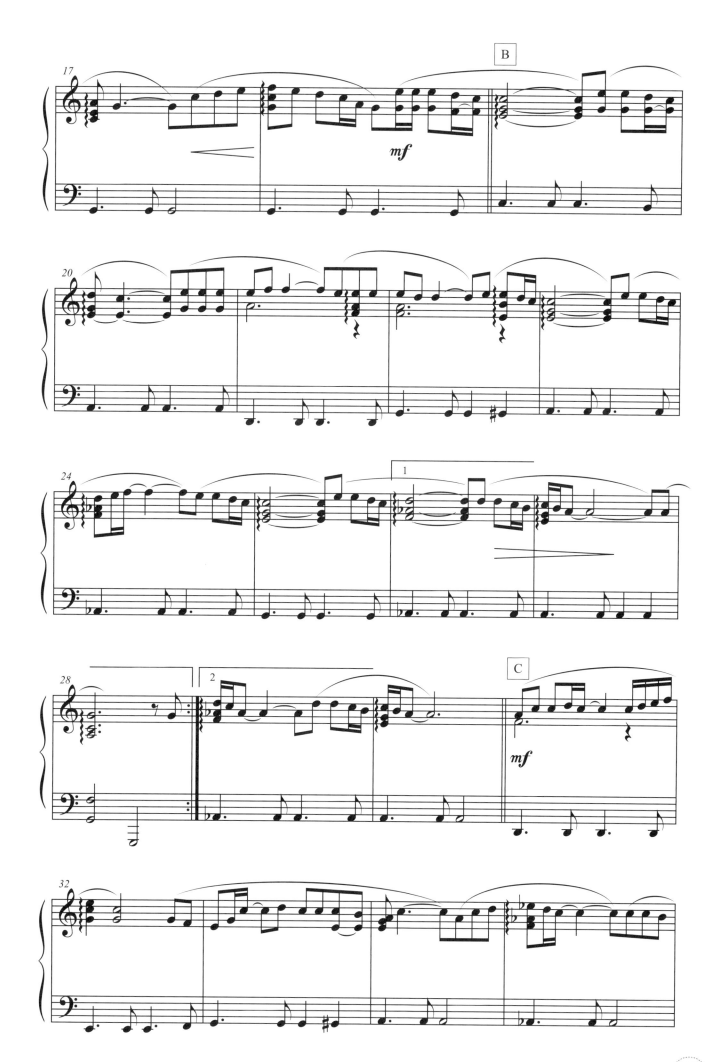

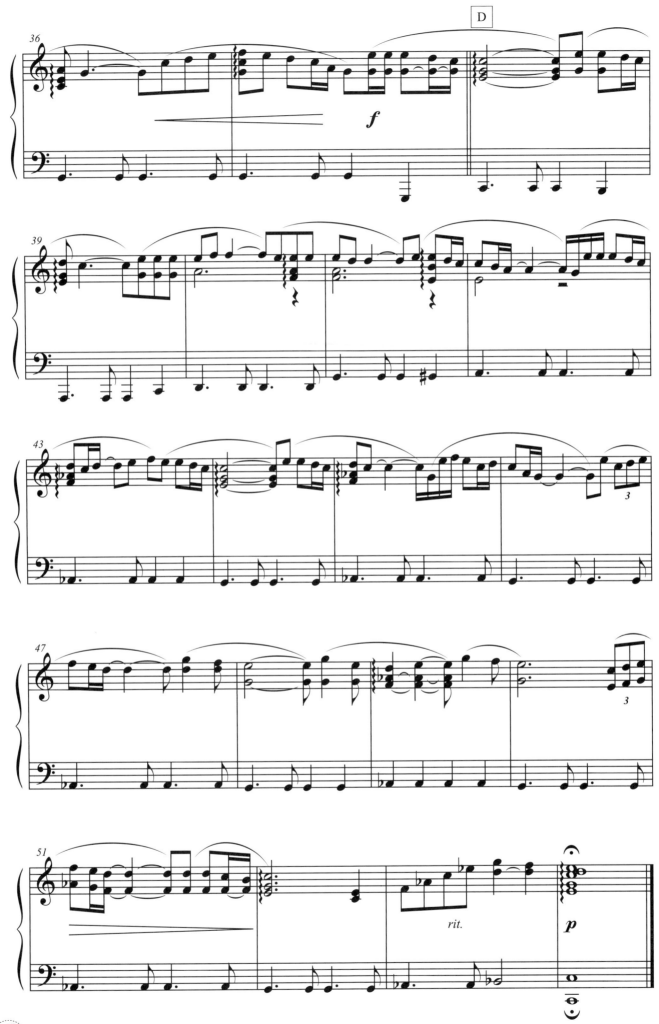

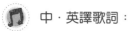

I used to think I could not go on
And life was nothing but an awful song
But now I know the meaning of true love
I'm leaning on the everlasting arm

我曾以為自己撐不下去
生命像一首變調的歌
如今我明白真愛的意義
找到能永遠倚靠的肩膀

If I can see it
Then I can do it
If I just believe it
There's nothing to it
I believe I can fly
I believe I can touch the sky
I think about it every night and day
Spread my wings and fly away
I believe I can soar
I see me running through that open door
I believe I can fly

只要看得見
我就能辦到
只要相信
就沒有難成的事
我相信我能飛
我相信我能觸摸到天空
我日夜思想
我要振翅飛翔
我相信我能飛
穿越那扇敞開的門
我相信我能飛

See I was on the verge of breaking down
Sometimes silence can seem so loud
There are miracles in life I must achieve
But first I know it starts inside of me

我曾瀕臨破滅
被寂寞壓得喘不過氣
我要創造生命的奇蹟
但我必須從心出發

If I can see it
Then I can do it
If I just believe it
There's nothing to it
I believe I can fly
I believe I can touch the sky
I think about it every night and day
Spread my wings and fly away
I believe I can soar
I see me running through that open door
I believe I can fly

只要看得見
我就能辦到
只要相信
就沒有難成的事
我相信我能飛
我相信我能觸摸到天空
我日夜思想
我要振翅飛翔
我相信我能飛
穿越那扇敞開的門
我相信我能飛

（Hey, cause I believe in you）

（因為我相信你）

If I just spread my wings
I can fly

只要展開雙翼
我就能飛翔

Reflection 倒影

【花木蘭】主題曲　Mulan

Track10

◆ 作曲：Jerry Goldsmith & Matthew Wilder

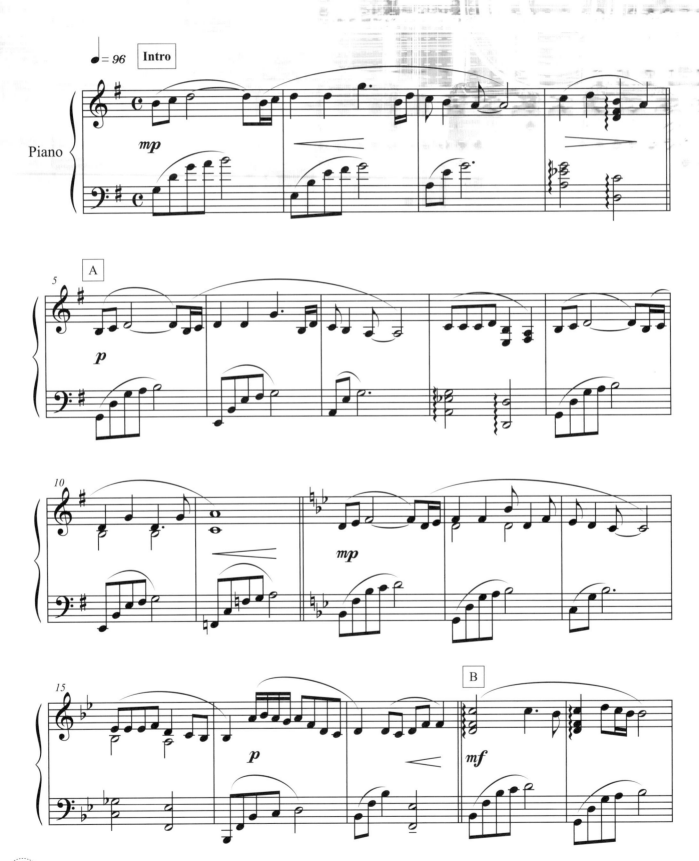

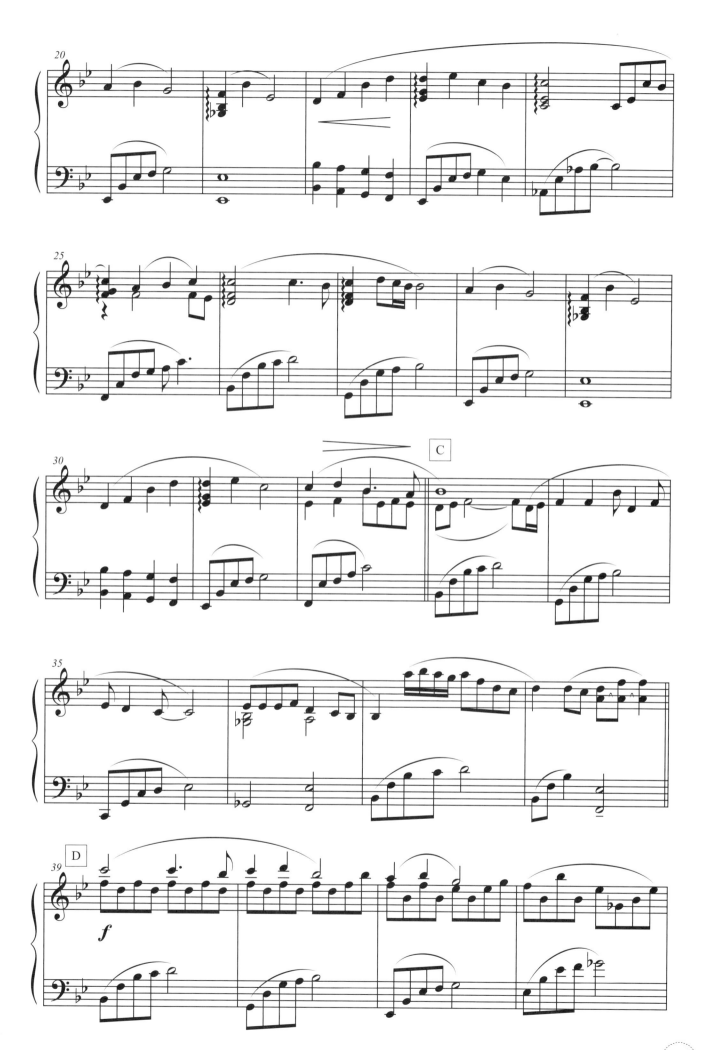

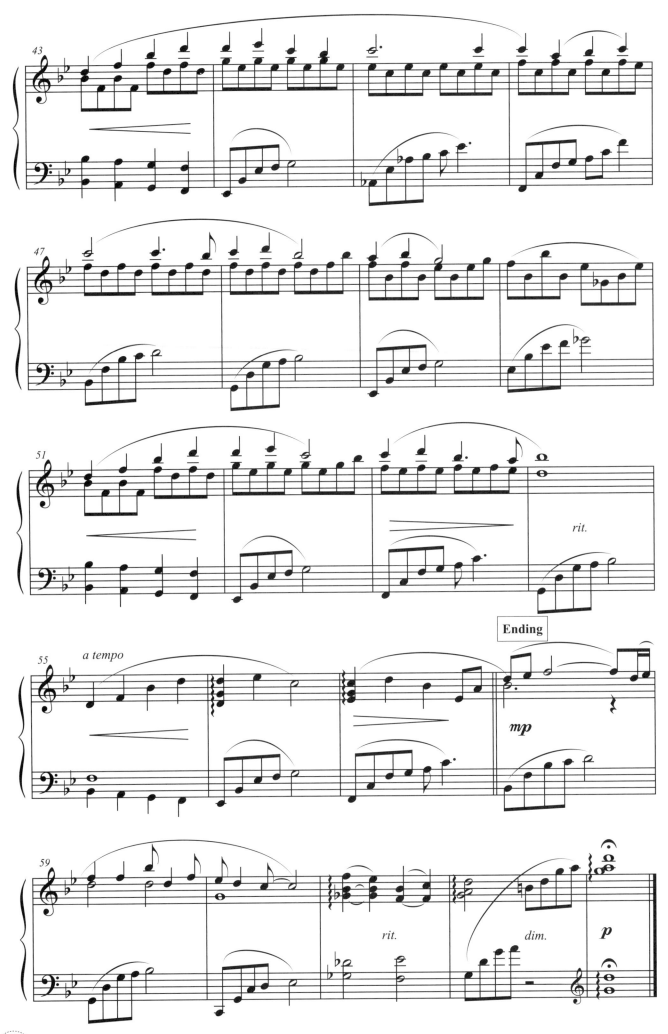

Ending

Look at me
I will never pass for a perfect bride
Or a perfect daughter
Can it be I'm not meant to play this part
Now I see that if I were truly to be myself
I would break my family's heart

Who is that girl I see staring straight back at me
Why is my reflection someone I don't know
Somehow I can not hide who I am
Though I've tried
When will my reflection show who I am inside
When will my reflection show who I am inside

看看我
我永遠當不了令人滿意的新娘
或令人滿意的女兒
或許我壓根兒投錯了胎
我發現 如果想做真正的自己
就會傷家人的心

盯著我看的女孩是誰
為何我連自己的倒影都不認識
不管我如何努力
就是無法掩藏自己
要到哪一天 我才能看見真正的自己
要到哪一天 我才能看見真正的自己

Shrek Theme 史瑞克主題曲

【史瑞克】主題曲　Shrek Theme

♪ Track11

◆ 作曲：John Powell & Harry Gregson-Williams

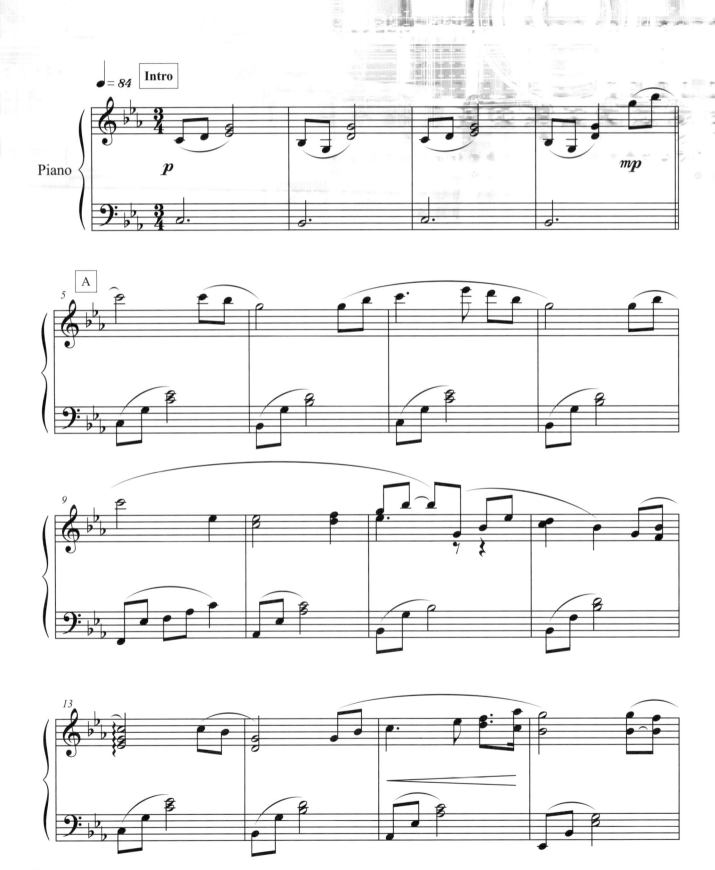

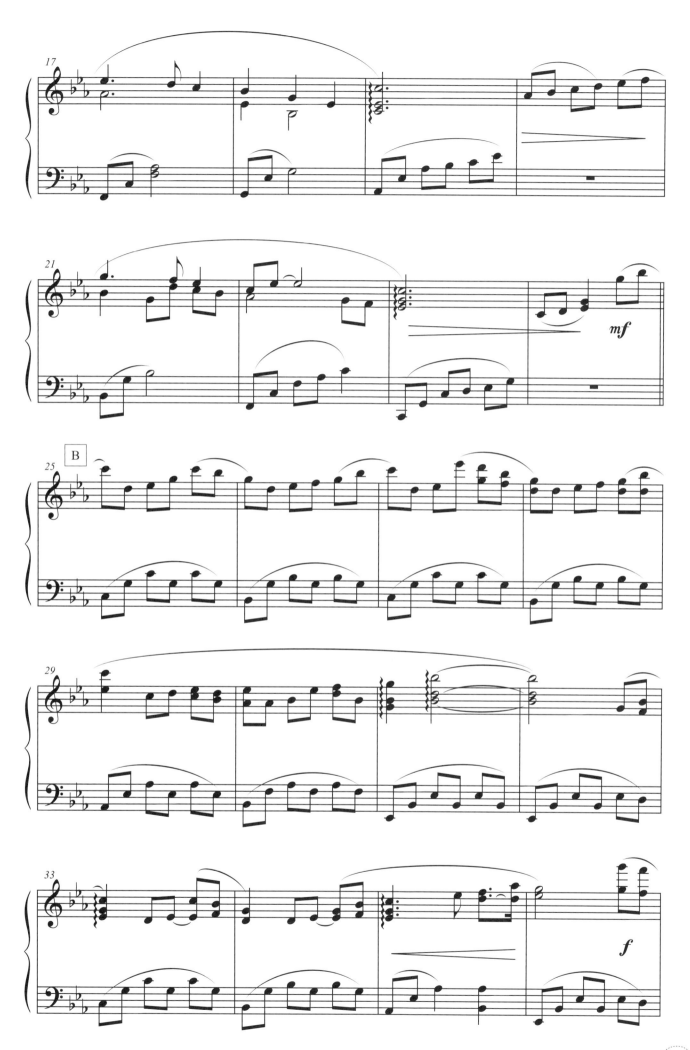

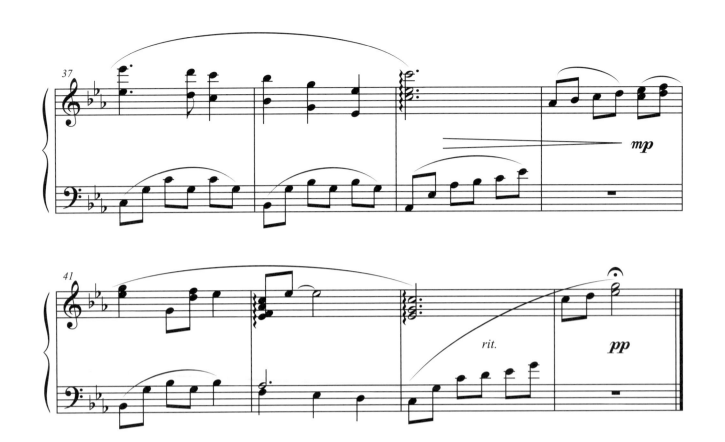

There is something that I see
In the way you look at me
There's a smile there's a truth in your eyes
What an unexpected way
On this unexpected day
Could it be, this is where I belong
It is you I have loved all along

There's no more mystery
It is finally clear to me
You're the home my heart searched for so long
It is you I have loved all along

There are times I ran to hide
Afraid to show the other side
Alone in the night without you
But now I know just who you are
And I know you hold my heart
Finally, this is where I belong
It is you I have loved all along

No more mystery
It is finally clear to me
You're the home my heart searched for so long
And It is you I have loved all along

Oh, over and over
I'm filled with emotion
Your love, it rushes through my veins
And I am filled with the sweetest devotion
As I look into your perfect face

There's no more mystery
It is finally clear to me
You're the home my heart searched for so long
It is you I have loved
It is you I have loved
It is you I have loved all along

從你的眼神中
我看見
你的笑和你的純真
多令人意外
多令人驚喜的日子
這是我的家
而你是我的愛

我不再疑惑
一切終於水落石出
你是我心渴望的歸屬
你是我唯一的愛

我曾逃跑躲藏
害怕在和你獨處的夜
顯露出真實的一面
但我已了解你
你珍惜我的心意
我已找到答案
你是我唯一的愛

我不再疑惑
一切終於水落石出
你是我心渴望的歸屬
你是我唯一的愛

一次又一次
我激動不已
你的愛填補我的空虛
帶給我最大的甜蜜
你的面容令我沉醉

我不再疑惑
一切終於水落石出
你是我心渴望的歸屬
你是我的愛
你是我的愛
你是我唯一的愛

Somewhere Out There 在某處

【美國鼠譚】主題曲　An American Tale

◆ 作曲：James Horner & Barry Mann

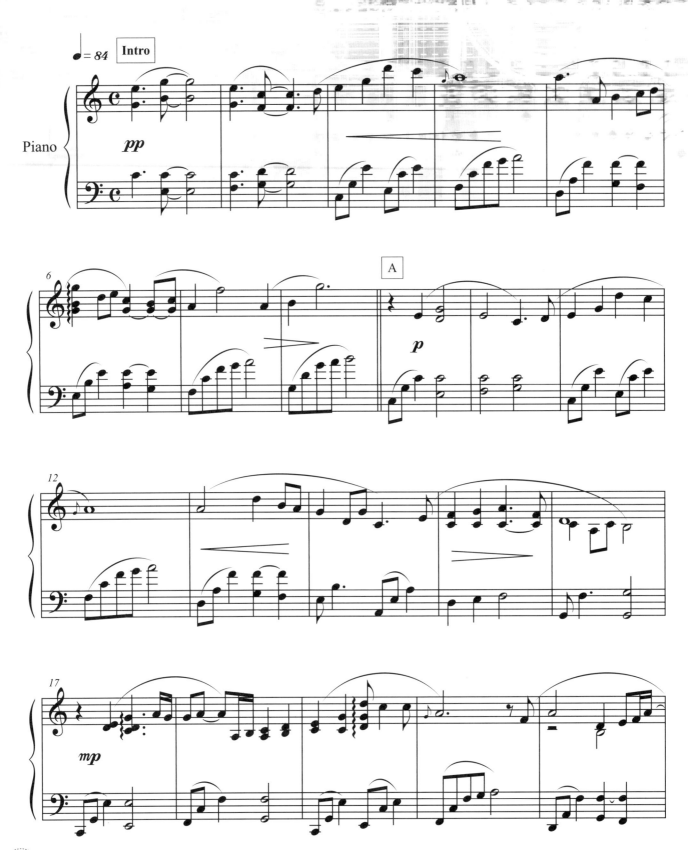

60

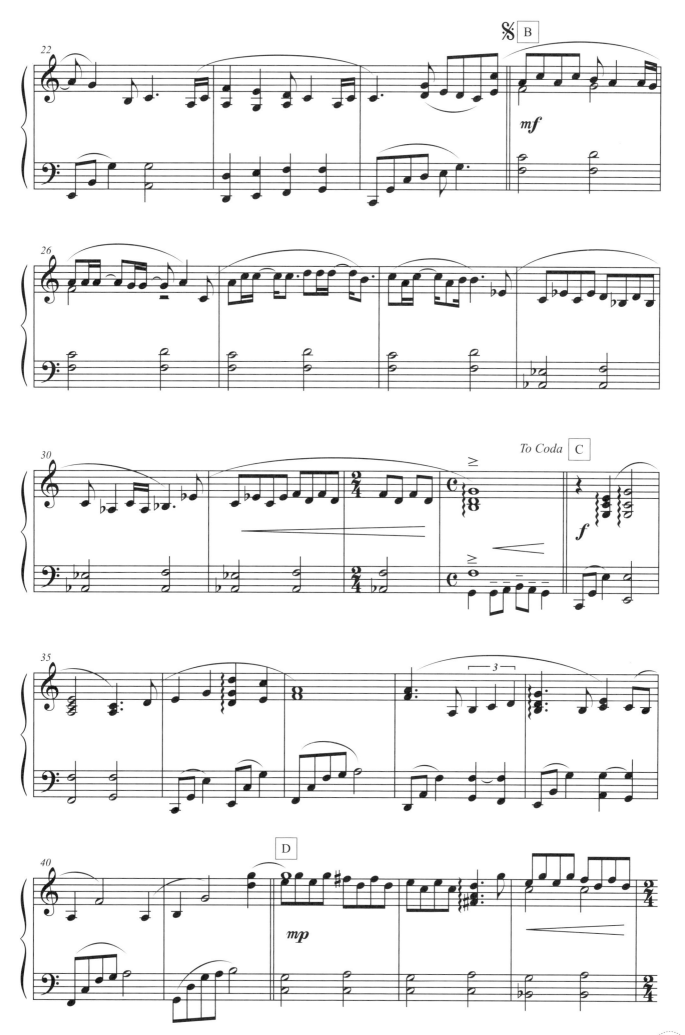

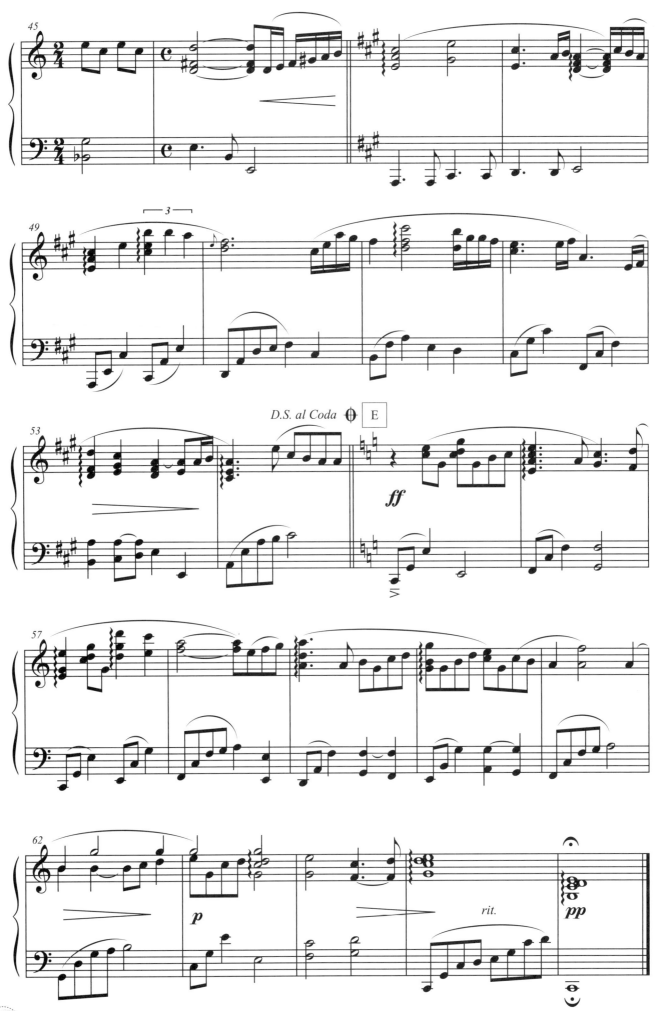

 中・英譯歌詞： **Somewhere Out There** 在某處

Somewhere out there	在某個地方
Beneath the pale moonlight	有昏黃的月光
Someone's thinking of me	有人正思念著我
And loving me tonight	愛著我
Somewhere out there	在某個地方
Someone's saying a prayer	有人正祈禱
That we'll find one another	我們將找到對方
In that big somewhere out there	就在那個地方
And even though I know how very far apart we are	儘管我們之間有遙遠的距離
It helps to think we might be wishing on the same bright star	至少還能對著同一顆星星許願
And when the night wind starts to sing a lonesome lullaby	當夜風輕唱搖籃曲
It helps to think we're sleeping	我們在同一座天空下
Underneath the same big sky	進入夢鄉
Somewhere out there	在某個地方
If love can see us through	愛讓我們度過難關
Then we'll be together	我們將在那裡相遇
Somewhere out there, out where dreams come true	那個美夢成真的地方

The Prayer　祈禱

【魔劍奇兵】主題曲　Quest For Camelot

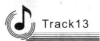
Track13

◆ 作曲：David Foster

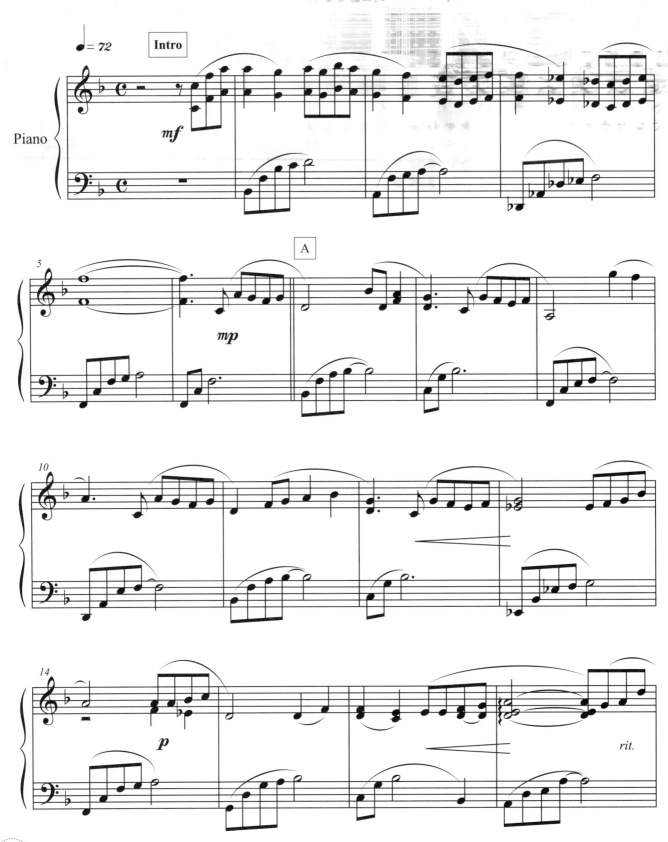

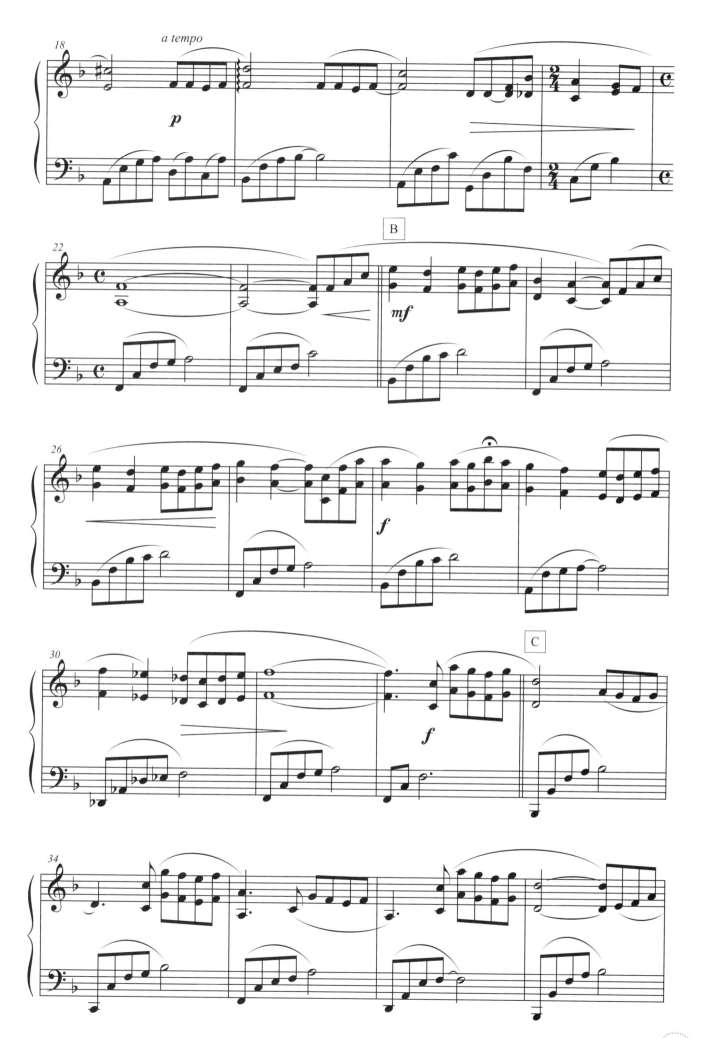

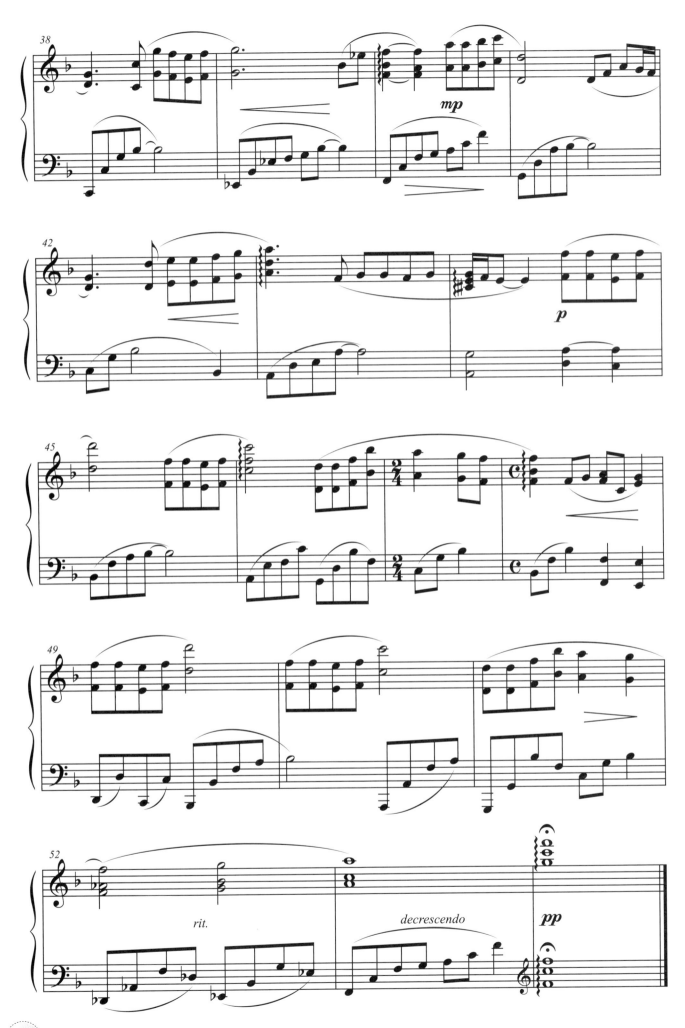

 The Prayer 祈禱

I pray you'll be our eyes
And watch us where we go
And help us to be wise
In times when we don't know
Let this be our prayer
When we lose our way
Lead us to the place
Guide us with your grace
To a place where we'll be safe

I pray we'll find your light
And hold it in our hearts
When stars go out each night
You are eternal star
Let this be our prayer
When shadows fill our day
Lead us to a place
Guide us with your grace
Give us faith so we'll be safe

求你做我們的眼睛
看顧我們的腳步
我們疑惑的時候
請賜給我們智慧
我們迷失的時候
這是我們的禱告
願你的恩典
領我們去應許之地
讓我們得著蔭庇

求你彰顯榮光
讓它長存我們心中
即使星光消逝
你仍舊閃耀
當前途烏雲密布
這是我們的禱告
願你的恩典
領我們去應許之地
堅信我們必得蔭庇

Under The Sea 海底深處

【小美人魚】主題曲　The Little Mermaid

Track14

◆ 作曲：Alan Menken

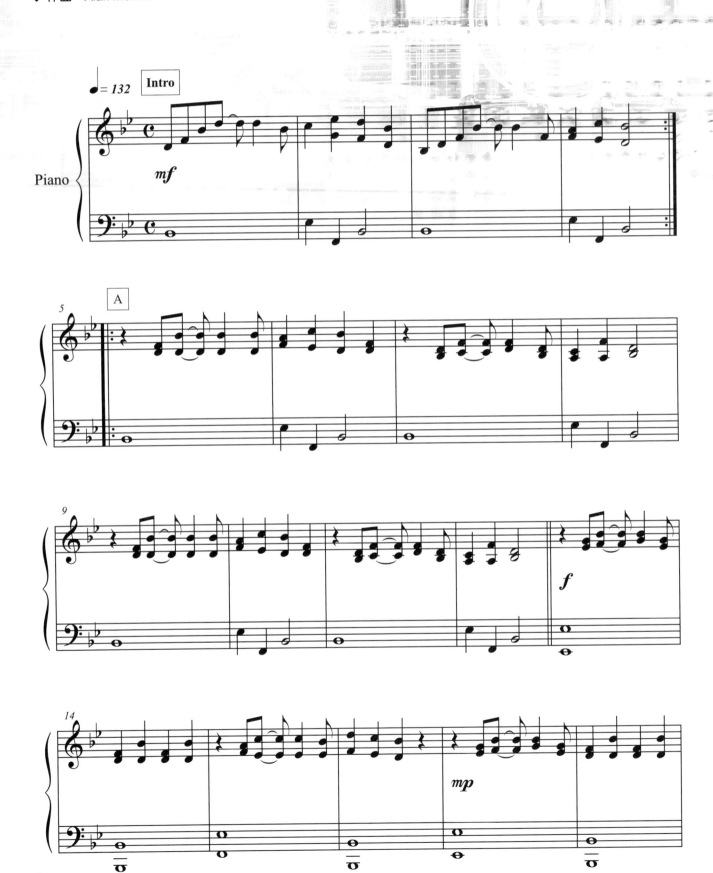

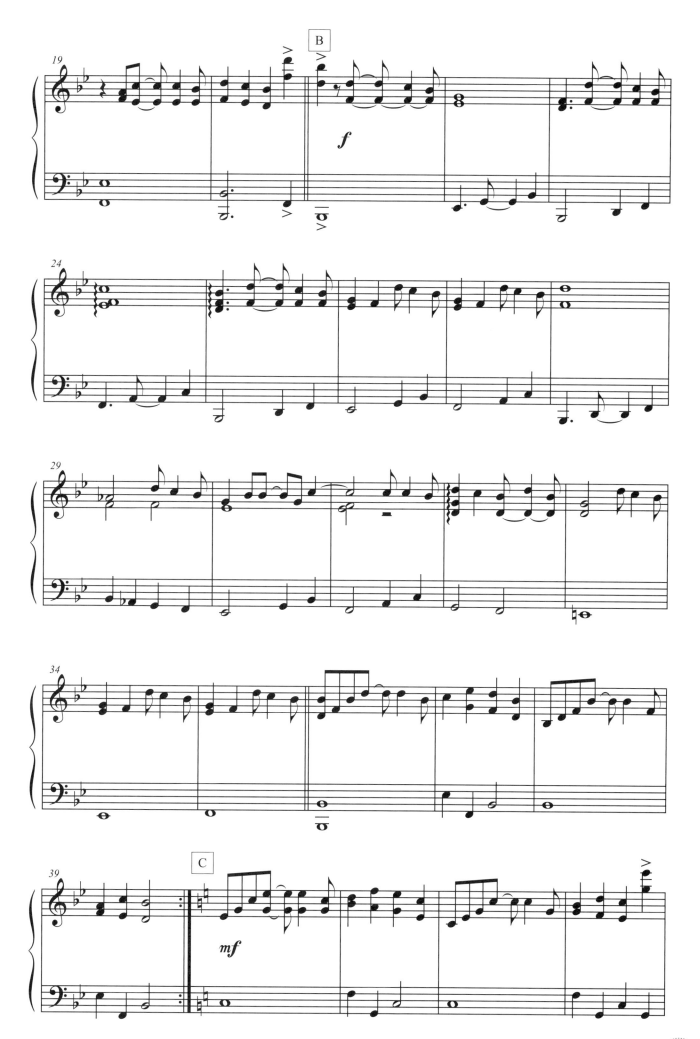

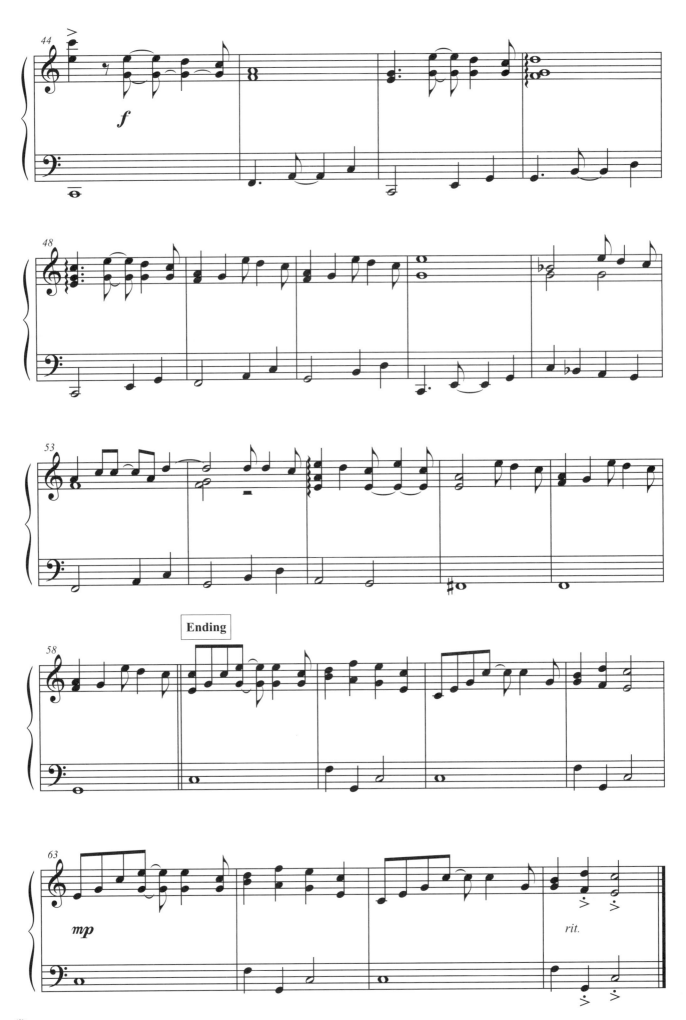

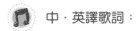 中·英譯歌詞： **Under The Sea** 海底深處

The seaweed is always greener, in somebody else's lake	湖泊裡的海藻似乎都比較綠 所以你夢想著離開
You dream about going up there, but that is a big mistake	但這是個天大的錯誤 看看你周圍的世界
Just look at the world around you	就在海洋深處
Right here on the ocean floor	這麼多美好的事物
Such wonderful things surround you	你還不滿足
What more are you looking for	在海底 在海底
Under the sea, under the sea	親愛的 看看這兒有多好
Darling it's better	海底世界水噹噹
Down where it's wetter	勸你還是留下吧
Take it from me	岸上的人們辛苦工作 在太陽底下揮汗如雨
Up on the shore they work all day; out in the sun they slave away	而我們整天快樂地浮潛
While we devoting, full time to floating	在海底
Under the sea	海底的魚兒很開心 在波浪間悠游來去
Down here all the fish are happy, as off through the waves day roll	岸上的魚兒不開心 整天被關在魚缸裡
The fish on the land ain't happy	魚缸裡的魚兒好運氣
They're sad 'cause they're in a bowl	有機會見識不幸中的不幸
But fish in the bowl is lucky	哪天牠們的主人肚子餓
They're in for a worser fate	某條魚就要倒大楣
One day when the boss gets hungry	在海底 在海底
Guess who's gonna be on the plate (uh-oh)	沒有人來尋晦氣 或把我們丟進煎鍋裡
Under the sea, under the sea	上了岸我們被抓去吃
Nobody beats us, fry us and eat us in fricassee	在海底可沒這回事
(We what) the land folks love to cook	生活輕鬆又燦爛 就像五顏六色的泡泡
Under the sea we off the hook	在海底 在海底
We got no troubles; life is the bubbles	海底的生活甜蜜蜜 節奏渾然天成
Under the sea, under the sea	鱘魚和魟魚
Since life is sweet here, we got the beat here naturally	忍不住開始奏樂
Even the sturgeon and the ray	我們的表演有看頭
They get the urge and start to play	你得親自下海聽
We got the spirit	水蛭吹長笛 鯉魚撥豎琴
You got to hear it under the sea	鰈魚彈貝斯 音樂多動聽
The newt play the flute; the carp play the harp	鱸魚吹銅管 鰾魚敲木盆
The plaice play the bass, and they're sounding sharp	比目魚精通靈魂樂（耶）
The bass play the brass; the chub play the tub	魟魚有才華 負責弦樂器
The fluke is the duke of soul (yeah)	鱒魚會跳舞 黑魚愛唱歌
The ray he can play; he lings on the strings	香魚和西鯡 節奏感十足
He trout rocking out; the blackfish she sings	哎唷 河豚生氣了
The smelt and the sprat, they know where it's at	在海底（在海底）
An'Oh, that blowfish blow	在海底（在海底）
Under the sea (under the sea)	沙丁魚跳比金舞
Under the sea (under the sea)	真精采
When the sardine begin the beguine	岸上的人只能看沙灘
It's music to me	我們早就在組樂團
What do they got, a lot of sand	這裡每隻小蛤蜊
We got a hot crustacean band	都知道怎樣軋一角
Each little clam here	這裡每條小蛞蝓
Know how to jam here under the sea	都有自己的天地
Each little slug here cutting a rug here under the sea	這裡每隻小蝸牛
Each little snail here knows how to wail here	都有自己的節奏
That's why it's hotter under the water	總之海底比較好
Ya we in luck here	我們真是好運氣
Down in the muck here under the sea	有幸生在大海底

When She Loved Me —當她仍愛我

【玩具總動員二】主題曲　Toy Story II

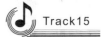

◆ 作曲：Randy Newman

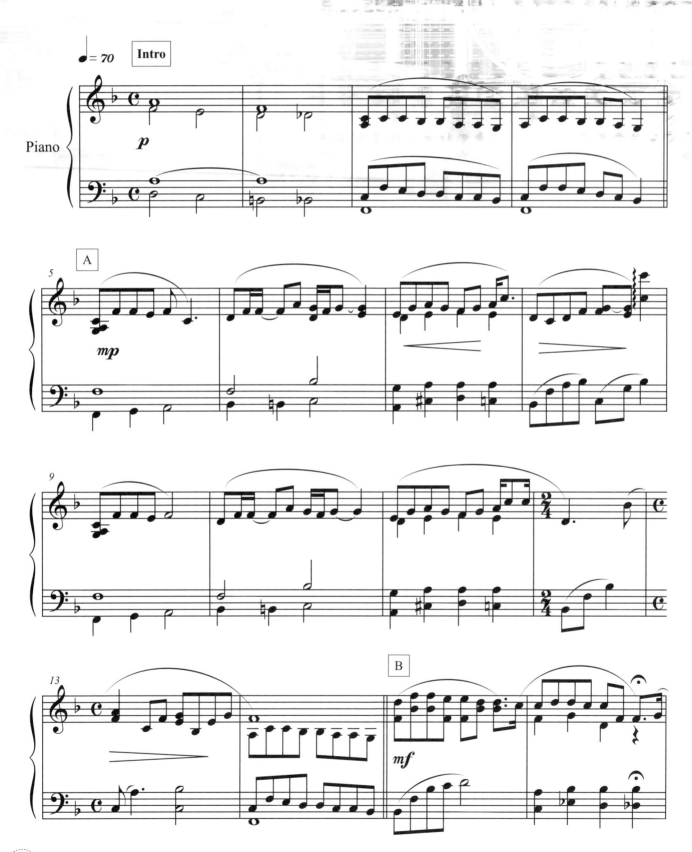

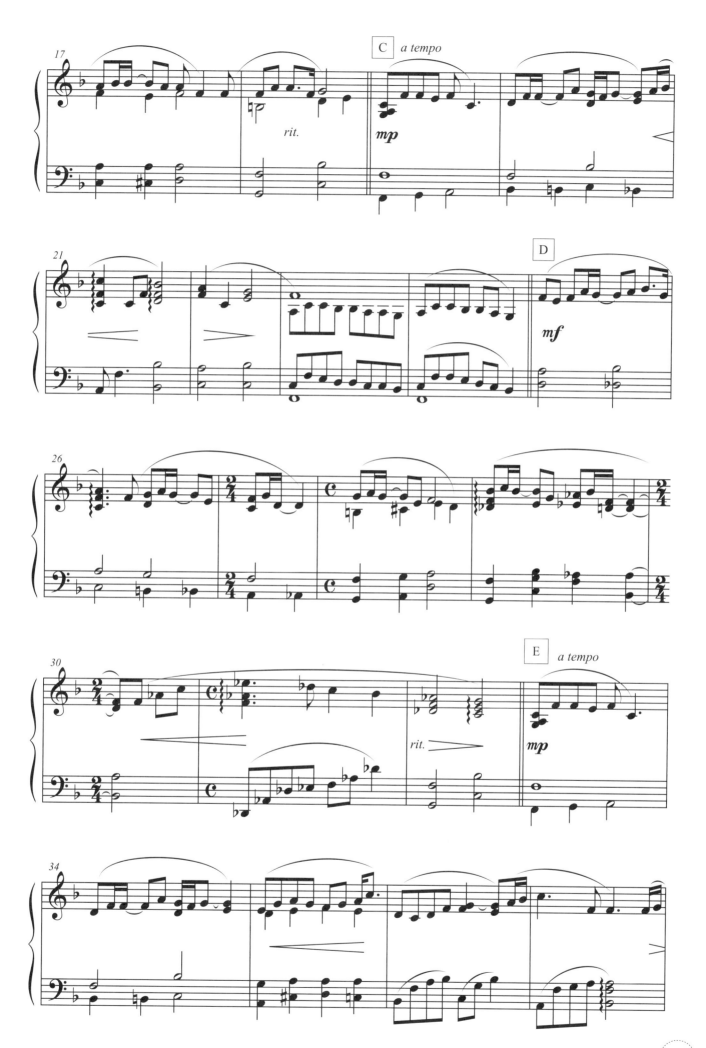

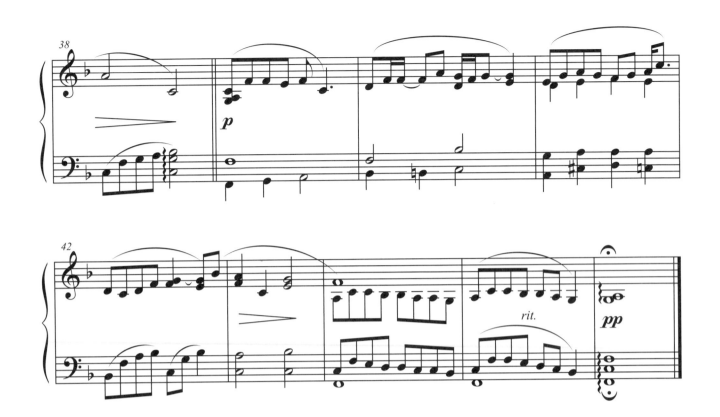

When She Loved Me 當她仍愛我

When somebody loved me	有人愛我的時候
Everything was beautiful	一切多美好
Every hour spent together	一起度過的每一分鐘
Lives within my heart	皆烙印在我心
And when she was sad	她傷心的時候
I was there to dry her tears	我擦乾她的眼淚
And when she was happy	她快樂
So was I	我也跟著歡喜
When she loved me	那她仍愛我
Through the summer and the fall	春去秋來
We had each other that was all	我們彼此依靠
Just she and I together	她和我的相遇
Like it was meant to be	似乎早已註定
And when she was lonely	她寂寞的時候
I was there to comfort her	我在一旁為她打氣
And I knew that she loved me	那時我確信她愛我
So the years went by	時光飛逝
I stayed the same	我從未改變
But she began to drift away	她卻越飛越遠
I was left alone	終於我被遺棄
Still I waited for the day	但我仍痴心地等
When she'd say "I will always love you"	等她說：「我永遠愛你」
Lonely and forgotten	孤單的我被冷落
Never thought she'd look my way	再不敢奢求她注意我
She smiled at me and held me	像她還愛我時那樣
Just like she used to do like she loved me	對我笑或擁抱我
When she loved me	但她曾愛過我
When somebody loved me	有人愛我的時候
Everything was beautiful	一切如此美好
Every hour spent together	一起度過的每一分鐘
Lives within my heart	皆烙印在我心
When she loved me	那她仍愛我

You'll Be In My Heart — 你永在我心

【泰山】主題曲　Tarzan

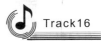

◆ 作曲：Phil Collins

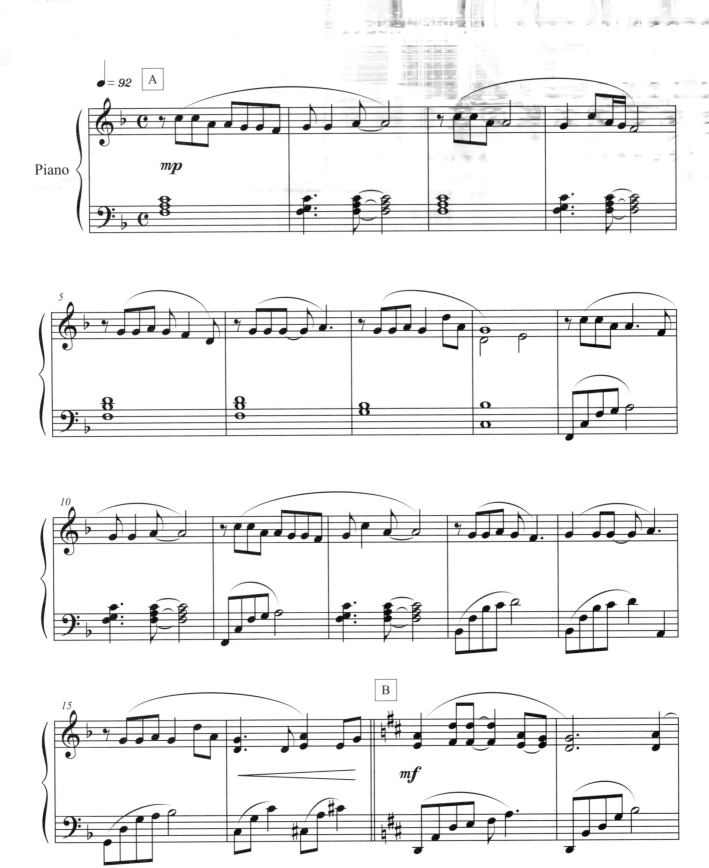

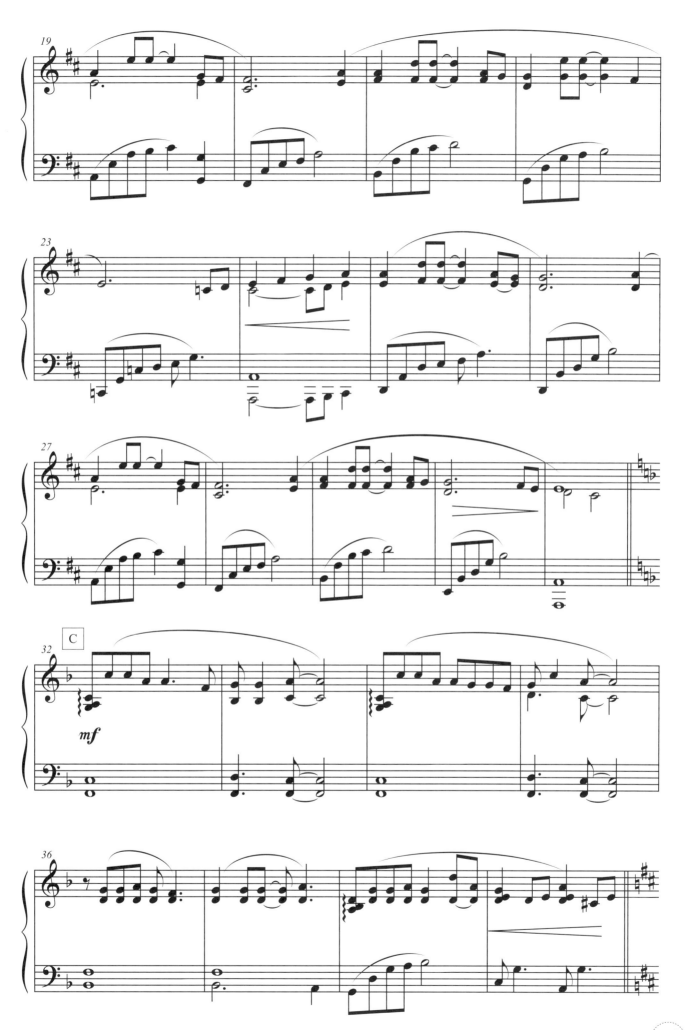

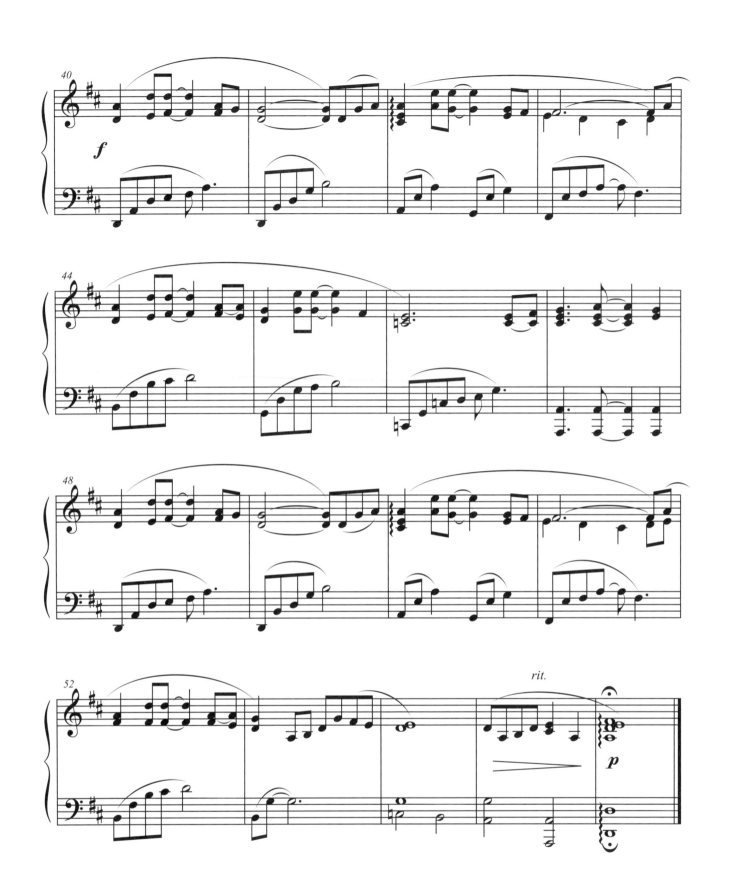

Come stop your crying It will be all right	別哭 沒事了
Just take my hand, hold it tight	牽我的手 握得緊緊的
I will protect you from all around you	我會保護你不受任何傷害
I will be here, don't you cry	有我在 別哭
For one so small, you seem so strong	小小的你 顯得如此強壯
My arms will hold you, keep you safe and warm	我會抱著你 給你安全和溫暖
This bond between us can't be broken	我們之間的緣分不能分割
I will be here, don't you cry	有我在 別哭
Cause you'll be in my heart	因為你在我心中
Yes, you'll be in my heart	是的 你在我心中
From this day on	從今天
Now and forever more	直到永遠
You'll be in my heart	你在我心中
No matter what they say	無論人們怎麼說
You'll be here in my heart, always	你在我心中 永永遠遠
Why can't they understand the way we feel	人們不了解我們的感受
They just don't trust what they can't explain	他們不信任自己無法理解的事物
I know we're different but deep inside us	我知道我們不一樣
We're not that different at all	但我們的心彼此相通
And you'll be in my heart	你在我心中
Yes, you'll be in my heart	是的 你在我心中
From this day on	從今天
Now and forever more	直到永遠
Don't listen to them, cause what do they know	別聽他們的 他們根本不懂
We need each other, to have and to hold	我們彼此需要 彼此擁有 彼此擁抱
They'll see in time, I know	他們遲早會明白
When destiny calls you, you must be strong	命運既呼召你 就得堅強
I may not be with you, but you gotta hold on	即使沒有我在身邊 也要堅持到底
They'll see in time, I know	他們遲早會明白
We'll show them together	我們會向他們證明
Cause you'll be in my heart	因為你在我心中
Believe me, you'll be in my heart	相信我 你在我心中
I'll be there from this day on	我會在這裡
Now and forever more oh oh	從今天直到永遠
You'll be here in my heart (You'll be here in my heart)	你在我心中（你在我心中）
No matter what they say (I'll be with you)	無論人們怎麼說（我在你身旁）
You'll be here in my heart	你在我心中
I'll be there always	我會一直在那兒
Always	直到永遠
I'll be with you	跟你在一起
I'll be there for you always	為你而守候
Always and always	亙古不移
Just look over your shoulder (3 X)	只要你抬頭張望
I'll be there always	我永遠在那裡

You've Got A Friend In Me　我是你的好朋友

【玩具總動員一】主題曲　Toy Story I

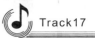

◆ 作曲：Randy Newman

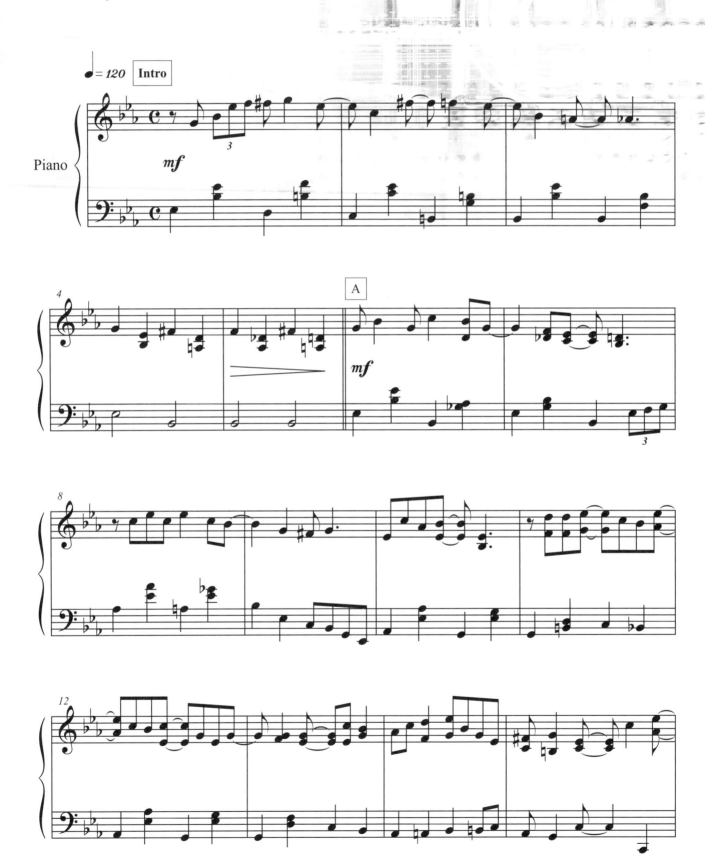

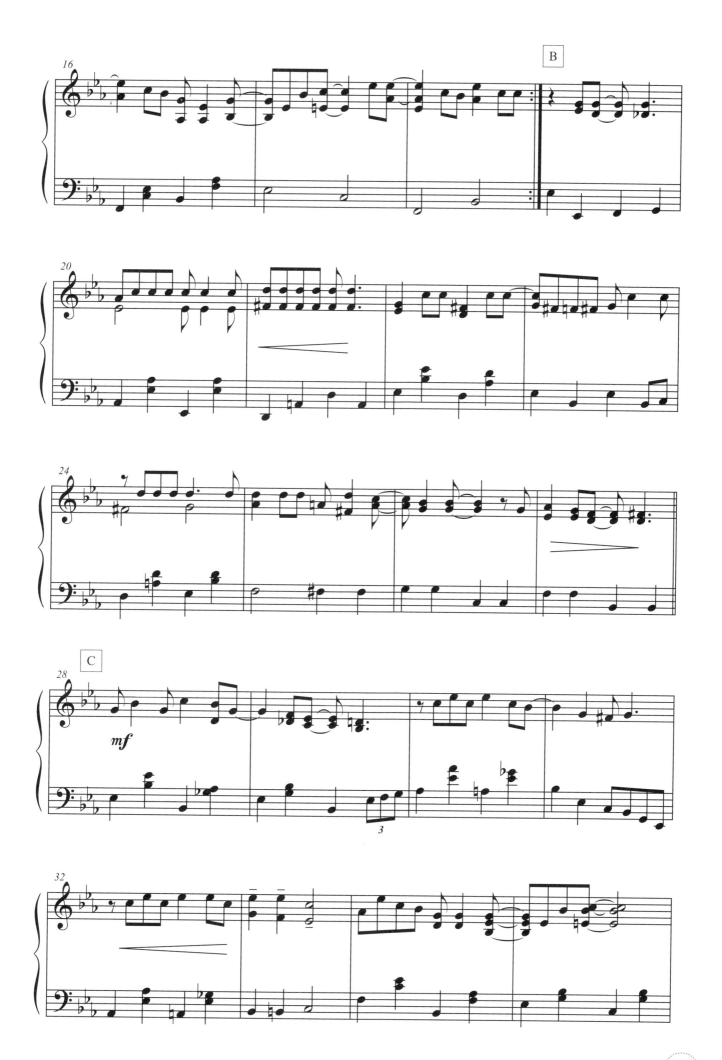

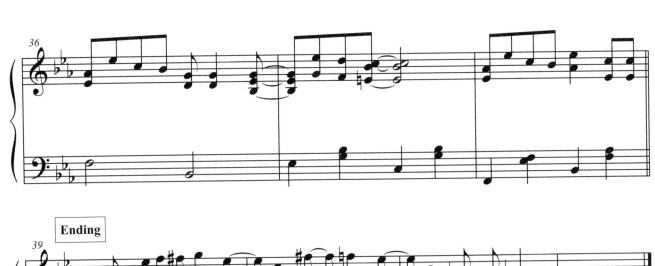

Ending

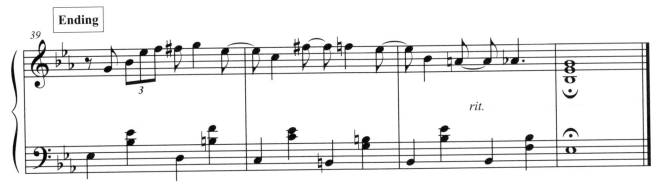

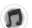

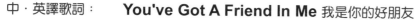

You've got a friend in me
You've got a friend in me
When the road looks rough ahead
And you're miles and miles from your nice warm bed
You just remember what your old pal said
Boy, you've got a friend in me
Yeah, you've got a friend in me

You've got a friend in me
You've got a friend in me
You've got troubles, and I've got 'em too
There isn't anything I wouldn't do for you
We stick together and see it through
Cause you've got a friend in me
You've got a friend in me

Some other folks might be a little bit smarter than I am
Bigger and stronger too
Maybe
But none of them will ever love you the way I do
It's me and you, boy
And as the years go by
Our friendship will never die
You're gonna see it's our destiny
You've got a friend in me

我是你的好朋友
我是你的好朋友
儘管前路崎嶇
你又離家千萬里
記得老友曾說
我是你的好朋友
沒錯 我是你的好朋友

我是你的好朋友
我是你的好朋友
我們有難同當
我願為你兩肋插刀
我倆不離不棄 共體時艱
因為我是你的好朋友
我是你的好朋友

別人可能比我聰明
比我高也比我壯
或許吧
但他們都不會像我這樣愛你
我們是分不開的
經歷時間的考驗
我們的友誼仍不變
你會發現這是命中註定
我是你的好朋友

When You Believe 當你相信

【埃及王子】主題曲　Prince of Egypt

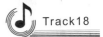

◆ 作曲：Stephen Schwarts

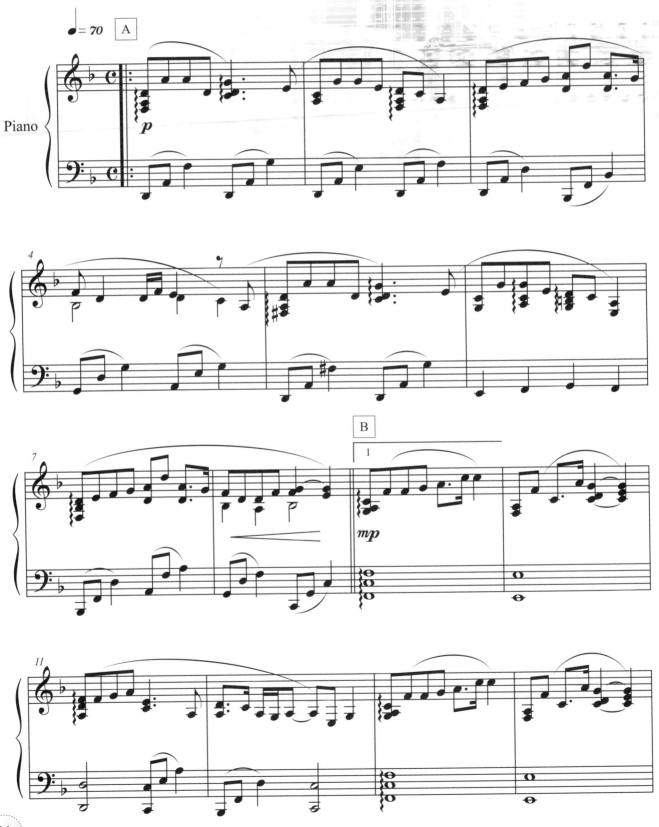

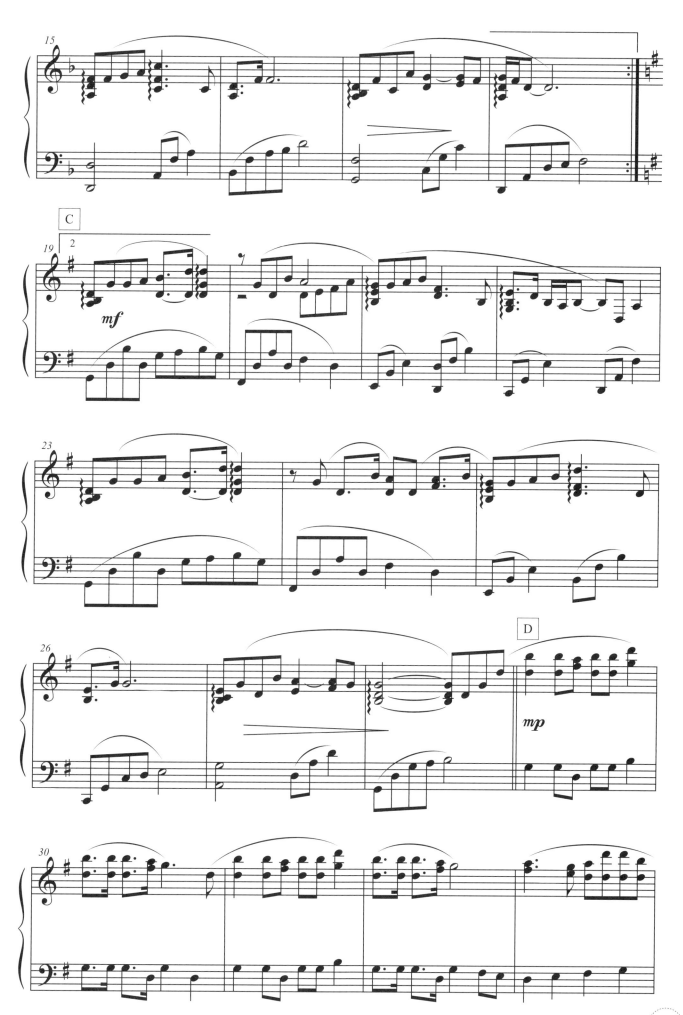

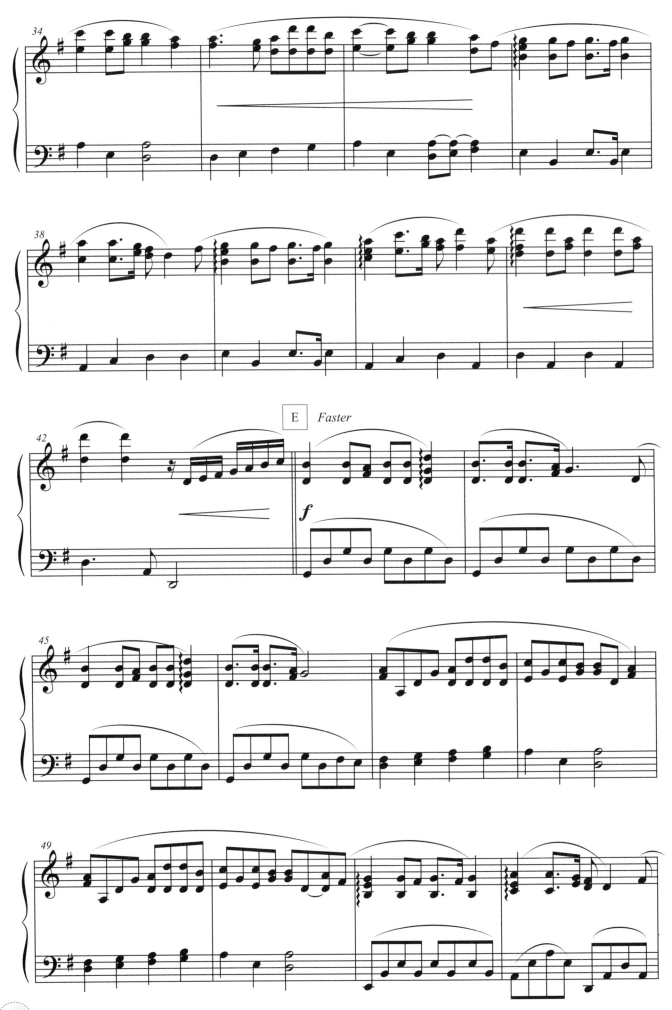

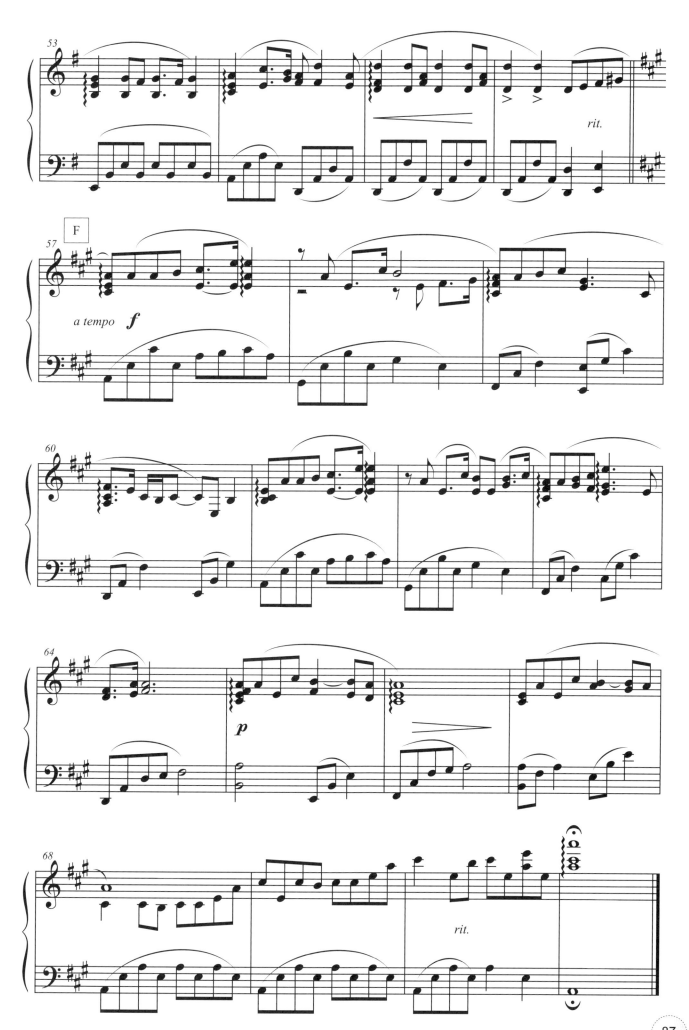

Many nights we've prayed	多少個夜裡我們祈禱
With no proof anyone could hear	不知是否有人聽到
In our hearts a hopeful song	心中響起一首希望的歌
We barely understood	超過我們所能理解
Now we are not afraid	如今我們再無疑懼
Although we know there's much to fear	儘管前方困難重重
We were moving mountains	我們還不清楚自己有多少能力
Long before we knew we could	便已成就大事
There can be miracles	有信心
When you believe	就有奇蹟
Though hope is frail	希望再渺茫
It's hard to kill	總還有希望
Who knows what miracles	你能創造的奇蹟
You can achieve	超乎你所求所想
When you believe	有信心
Somehow you will	就能創造奇蹟
You will when you believe	只要你相信
In this time of fear	我們心中害怕
When prayer so often proved in vain	因為並非每個禱告都蒙應允
Hope seemed like the summer birds	希望像夏天的候鳥
Too swiftly flown away	稍縱即逝
Yet now I'm standing here	然而我今天站在這裡
With heart so full I can't explain	信心如此強烈
Seeking faith and speaking words	堅定的信仰和大能的言語
I never thought I'd say	連自己都驚訝
There can be miracles	有信心
When you believe	就有奇蹟
Though hope is frail	希望再渺茫
It's hard to kill	總還有希望
Who knows what miracles	你能創造的奇蹟
You can achieve	超乎你所求所想
When you believe	有信心
Somehow you will	就能創造奇蹟
You will when you believe	只要你相信

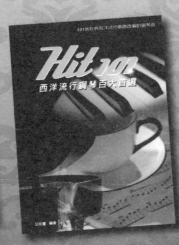

麥書文化

最新圖書目錄

學習音樂最佳途徑
音樂人必備叢書
專業樂譜

COMPLETE CATALOGUE

鋼琴系列

書名	編著/定價	說明
新世紀鋼琴古典名曲30選（另有簡譜版）	何真真、劉怡君 編著 定價360元 2CD	編者收集並改編各時期知名作曲家最受歡迎的曲目。註解歷史源由與社會背景，更有編曲技巧說明。附有CD音樂的完整示範。
新世紀鋼琴台灣民謠30選（另有簡譜版）	何真真 編著 定價360元 2CD	編者收集並改編台灣經典民謠歌曲。每首歌都附有歌詞，描述當時台灣的社會背景，更有編曲解析。本書另附有CD音樂的完整示範。
電影主題曲30選（另有簡譜版）30 Movie Theme Songs Collection	朱怡潔 編著 定價320元	30部經典電影主題曲，「B.J.單身日記：All By Myself」、「不能說的，秘密：Secret」、「魔戒三部曲：魔戒組曲」……等。電影大綱簡介、配樂介紹與曲目賞析。
婚禮主題曲30選 30 Wedding Songs Collection	朱怡潔 編著 定價320元	精選30首適合婚禮選用之歌曲，〈愛的禮讚〉、〈人海中遇見你〉、〈My Destiny〉、〈今天你要嫁給我〉……等，附樂曲介紹及曲目賞析。
鋼琴和弦百科 Piano Chord Encyclopedia	麥書文化編輯部 編著 定價200元	漸進式教學，深入淺出了解各式和弦，並以簡單明瞭和弦方程式，讓你了解各式和弦的組合方式，每個單元都有配合的應用練習題，讓你加深記憶、舉一反三。

民謠彈唱系列

書名	編著/定價	說明
彈指之間 Guitar Handbook	潘尚文 編著 定價380元 附影音教學 QR Code	吉他彈唱、演奏入門教本，基礎進階完全自學。精選中文流行、西洋流行等必練歌曲。理論、技術循序漸進，吉他技巧完全攻略。
指彈好歌 Great Songs And Fingerstyle	吳進興 編著 定價400元	附各種節奏詳細解說、吉他編曲教學，是基礎進階學習者最佳教材，收錄中西流行必練歌曲、經典指彈歌曲。且附前奏影音示範、原曲仿真編曲QRCode連結。
就是要彈吉他	張雅惠 編著 定價240元	作者超過30年教學經驗，讓你30分鐘內就能自彈自唱！本書有別於以往的教學方式，僅需記住4種和弦按法，就可以輕鬆入門吉他的世界！
六弦百貨店精選3 Guitar Shop Song Collection	潘尚文、盧家宏 編著 定價360元	收錄年度華語暢銷排行榜歌曲，內容涵蓋六弦百貨歌曲精選。專業吉他TAB譜六線套譜，全新編曲，自彈自唱的最佳叢書。
六弦百貨店精選4 Guitar Shop Special Collection 4	潘尚文 編著 定價360元	精采收藏16首絕佳吉他編曲流行彈唱歌曲－獅子合唱團、盧廣仲、周杰倫、五月天……一次收藏32首獨立樂團歷年最經典歌曲－茄子蛋、逃跑計劃、草東沒有派對、老王樂隊、滅火器、麋先生……
I PLAY詩歌－MY SONGBOOK Top 100 Greatest Hymns Collection	麥書文化編輯部 編著 定價360元	收錄經典福音聖詩、敬拜讚美好聽和弦編配，敬拜更增氣氛。內附吉他、鍵盤樂器、烏克麗麗，各調性和弦級數對照表。
節奏吉他完全入門24課 Complete Learn To Play Rhythm Guitar Manual	顏鴻文 編著 定價400元 附影音教學 QR Code	詳盡的音樂節奏分析、影音示範，各類型常用音樂風格吉他伴奏方式解說，活用樂理知識，伴奏更為生動！

木吉他演奏系列

書名	編著/定價	說明
指彈吉他訓練大全 Complete Fingerstyle Guitar Training	盧家宏 編著 定價460元 DVD	第一本專為Fingerstyle學習所設計的教材，從基礎到進階，涵蓋各類樂風編曲手法、經典範例，隨書附教學示範DVD。
吉他新樂章 Finger Stlye	盧家宏 編著 定價550元 CD+VCD	18首最膾炙人口的電影主題曲改編而成的吉他獨奏曲，詳細五線譜、六線譜、和弦指型、簡譜完整對照並行之超級套譜，附贈精彩教學VCD。
吉樂狂想曲 Guitar Rhapsody	盧家宏 編著 定價550元 CD+VCD	12首日韓劇主題曲超級樂譜，五線譜、六線譜、和弦指型、簡譜全部收錄。彈奏解說、單音版曲譜，簡單易學，附CD、VCD。

古典吉他系列

書名	編著/定價	說明
樂在吉他 Joy With Classical Guitar	楊昱泓 編著 定價360元 附影音教學 QR Code	本書專為初學者設計，學習古典吉他從零開始。詳盡的樂理、音樂符號術語解說、吉他音樂家小故事，完整收錄卡爾卡西二十五首練習曲，並附詳細解說。
古典吉他名曲大全（一）（二）（三）Guitar Famous Collections No.1 / No.2 / No.3	楊昱泓 編著 每本定價550元 DVD+MP3	收錄多首古典吉他名曲，附曲目簡介、演奏技巧提示，由留法名師示範彈奏。五線譜、六線譜對照，無論民謠吉他或古典吉他，皆可體驗彈奏名曲的感受。
新編古典吉他進階教程 New Classical Guitar Advanced Tutorial	林文前 編著 定價550元 DVD+MP3	收錄古典吉他之經典進階曲目，可作為卡爾卡西的銜接教材，適合具備古典吉他基礎者學習。五線譜、六線譜對照，附影音演奏示範。

吹管樂器系列

書名	編著/定價	說明
口琴大全－複音初級教本 Complete Harmonica Method	李孝明 編著 定價360元 DVD+MP3	複音口琴初級入門標準本，適合21-24孔複音口琴。深入淺出的技術圖示、解說，全新DVD影像教學版，最全面性的口琴自學寶典。
陶笛完全入門24課 Complete Learn To Play Ocarina Manual	陳若儀 編著 定價360元 DVD+MP3	輕鬆入門陶笛一學就會！教學簡單易懂，內容紮實詳盡，隨書附影音教學示範，學習樂器完全無壓力快速上手！
豎笛完全入門24課 Complete Learn To Play Clarinet Manual	林姿均 編著 定價400元 附影音教學 QR Code	由淺入深、循序漸進地學習豎笛。詳細的圖文解說、影音示範吹奏要點。精選多首耳熟能詳的民謠及流行歌曲。
長笛完全入門24課 Complete Learn To Play Flute Manual	洪敬婷 編著 定價400元 附影音教學 QR Code	由淺入深、循序漸進地學習長笛。詳細的圖文解說、影音示範吹奏要點。精選多首耳影劇配樂、古典名曲。

電貝士系列

書名	編著/定價	說明
電貝士完全入門24課 Complete Learn To Play E.Bass Manual	范漢威 編著 定價360元 DVD+MP3	電貝士入門教材，教學內容由淺入淺、循序漸進，隨書附影音教學示範DVD。
The Groove The Groove	Stuart Hamm 編著 定價800元 教學DVD	本世紀最偉大的Bass宗師「史都翰」電貝斯教學DVD，多機數位影音、全中文字幕。收錄5首「史都翰」精采Live演奏及完整貝斯四線套譜。
放克貝士彈奏法 Funk Bass	范漢威 編著 定價360元 CD	最貼近實際音樂的練習材料，最健全的系統學習與流程方法。30組全方位完正訓練課程，超高效率提升彈奏能力與音樂認知，內附音樂學習光碟。
搖滾貝士 Rock Bass	Jacky Reznicek 編著 定價360元 CD	電貝士的各式技巧解說及各式曲風教學。CD內含超過150首關於搖滾、藍調、靈魂樂、放克、雷鬼、拉丁和爵士的練習曲和基本律動。

新書系列

二胡入門三部曲
By 3 Step To Playing Erhu
黃子銘 編著　定價400元 附影音教學 QR Code
教學方式創新，由G調第二把位入門。簡化基礎練習，針對重點反覆練習。課程循序漸進，按部就班輕鬆學習。收錄63首經典民謠、國台語流行歌曲。精心編排，最佳閱讀舒適度。

烏克麗麗系列

烏克麗麗完全入門24課
Complete Learn To Play Ukulele Manual
陳建廷 編著　定價360元 附影音教學 QR Code
烏克麗麗輕鬆入門一學就會，教學簡單易懂，內容紮實詳盡，隨書附贈影音教學示範，學習樂器完全無壓力快速上手！

快樂四弦琴1
Happy Uke
潘尚文 編著　定價320元 附示範音樂下載QR code
夏威夷烏克麗麗彈奏法標準教材，適合兒童學習。徹底學「搖擺、切分、三連音」三要素。

烏克城堡1
Ukulele Castle
龍映育 編著　定價320元 DVD
從建立節奏感和音到認識音符、音階和旋律，每一課都用心規劃歌曲、故事和遊戲。附有教學MP3檔案，突破以往制式的伴唱方式，結合烏克麗麗與木箱鼓，加上大提琴跟鋼琴伴奏，讓老師進行教學、說故事和帶唱遊活動時更加多變化！

烏克麗麗民歌精選
Ukulele Folk Song Collection
張國霖 編著　每本定價400元
精彩收錄70-80年代經典民歌99首。全書以C大調採譜，彈奏簡單好上手！譜面閱讀清晰舒適，精心編排減少翻閱次數。附常用和弦表、各調音階指板圖、常用節奏&指法。

烏克麗麗名曲30選
30 Ukulele Solo Collection
盧家宏 編著　定價360元 DVD+MP3
專為烏克麗麗獨奏而設計的演奏套譜，精心收錄30首名曲，隨書附演奏DVD+MP3。

I PLAY－MY SONGBOOK音樂手冊
I PLAY－MY SONGBOOK
潘尚文 編著　定價360元
收錄102首中文經典及流行歌曲之樂譜，保有原曲風格、簡譜完整呈現，各項樂器演奏皆可。

烏克麗麗指彈獨奏完整教程
The Complete Ukulele Solo Tutorial
劉宗立 編著　定價360元 DVD
詳述基本樂理知識、102個常用技巧，配合高清影片示範教學，輕鬆易學。

烏克麗麗二指法完美編奏
Ukulele Two-finger Style Method
陳建廷 編著　定價360元 DVD+MP3
詳細彈奏技巧分析，並精選多首歌曲使用二指法重新編奏，二指法影像教學、歌曲彈奏示範。

烏克麗麗大教本
Ukulele Complete textbook
龍映育 編著　定價400元 DVD+MP3
有系統的講解樂理觀念，培養編曲能力，由淺入深地練習指彈技巧，基礎的指法練習、對拍彈唱、視譜訓練。

烏克麗麗彈唱寶典
Ukulele Playing Collection
劉宗立 編著　定價400元
55首熱門彈唱曲譜精心編配，包含完整前奏間奏，還原Ukulele最純正的編曲和演奏技巧。詳細的樂理知識解說，清楚的演奏技法教學及示範影音。

電吉他系列

爵士吉他完全入門24課
Complete Learn To Play Jazz Guitar Manual
劉旭明 編著　定價360元 DVD+MP3
爵士吉他速成教材，24週養成基本爵士彈奏能力，隨書附影音教學示範DVD。

電吉他完全入門24課
Complete Learn To Play Electric Guitar Manual
劉旭明 編著　定價400元 附影音教學 QR Code
電吉他輕鬆入門，教學內容紮實詳盡，掃描書中QR Code即可線上觀看教學示範。

主奏吉他大師
Masters of Rock Guitar
Peter Fischer 編著　定價360元 CD
書中講解大師必備的吉他演奏技巧，描述不同時期各個頂級大師演奏的風格與特點，列舉大量精彩作品，進行剖析。

節奏吉他大師
Masters of Rhythm Guitar
Joachim Vogel 編著　定價360元 CD
來自頂尖大師的200多個不同風格的演奏Groove，多種不同吉他的節奏理念和技巧，附CD。

搖滾吉他秘訣
Rock Guitar Secrets
Peter Fischer 編著　定價360元 CD
書中講解蜘蛛爬行手指熱身練習、搖桿俯衝轟炸、即興創作、各種調式音階、神奇音階、雙手點指等技巧教學。

前衛吉他
Advance Philharmonic
劉旭明 編著　定價600元 2CD
從基礎電吉他技巧到各種音樂觀念、型態的應用。最扎實的樂理觀念、最實用的技巧、音階、和弦、節奏、調式訓練，吉他技術完全自學。

現代吉他系統教程Level 1～4
Modern Guitar Method Level 1~ 4
劉旭明 編著　每本定價500元 2CD
第一套針對現代音樂的吉他教學系統，完整音樂訓練課程，不必出國就可體驗美國MI的教學系統。

調琴聖手
Guitar Sound Effects
陳慶民、華育棠 編著　定價400元 附示範音樂 QR Code
最完整的吉他效果器調校大全。各類吉他及擴大機特色介紹、各類型效果器完整剖析、單踏板效果器串接實戰運用。內附示範演奏音樂連結，掃描QR Code。

音樂製作系列

專業音響實務秘笈
Professional Audio Essentials
陳榮貴 編著　定價500元
華人第一本中文專業音響的學習書籍。作者以實際使用與銷售專業音響器材的經驗，融匯專業音響知識，以最淺顯易懂的文字和圖片來解釋專業音響知識。內容包括混音機、麥克風、喇叭、效果器、等化器、系統設計...等等的專業知識及相關理論。

專業音響X檔案
陳榮貴 編著　定價500元
專業影音技術詞彙、術語中文解說。專業音響、影視廣播、成音工作者必備工具書。A To Z按字母順序查詢，圖文並茂簡單而快速。音樂人人手必備工具書！

錄音室的設計與裝修
劉連 編著　定價680元
室內隔音設計寶典，錄音室、個人工作室裝修實例。琴房、樂團練習室、音響視聽室隔音要訣。全球知名錄音室設計典範。

DJ唱盤入門實務
The DJ Starter Handbook
楊立鈦 編著　定價500元 附影音教學 QR Code
從零開始，輕鬆入門－認識器材、基本動作與知識。演奏唱盤；掌控節奏－Scratch刷碟技巧與Flow、Beat Juggling；創造律動，玩轉唱盤－抓拍與丟拍、提升耳朵判斷力、Remix。

運動生活系列

一次就上手的快樂瑜伽
四週課程計畫（全身雕塑版）
HIKARU 編著　林宜薰 譯　定價320元 附DVD
教學影片動作解說淺顯易懂，即使第一次練瑜珈也能持續下去的四週課程計畫！訣竅輕易掌握，了解對身體雕塑有效的姿勢！在家看DVD進行練習，也可掃描書中QRCode立即線上觀看。

室內肌肉訓練
森 俊憲 編著　林宜薰 譯　定價280元 附DVD
一天5分鐘，在自家就能做到的肌肉訓練！針對無法堅持的人士，也詳細解說維持的秘訣！無論何時何地都能實行，2星期就實際感受體型變化！

少年足球必勝聖經
柏太陽神足球俱樂部 主編　林宜薰 譯　定價350元 附DVD
源自柏太陽神足球俱樂部青訓營的成功教學經驗。足球技術動作以清楚圖解進行說明。可透過DVD動作示範影片定格來加以理解，示範影片皆可掃描書中QRCode線上觀看。

www.musicmusic.com.tw

朱怡潔、吳逸芳 編著

每本 定價320元

劇「交響情人夢」、「交響情人夢－巴黎篇」、
交響情人夢－最終樂章前篇」、「交響情人夢－
終樂章後篇」，經典古典曲目完整一次收錄，內
巴哈、貝多芬、林姆斯基、莫札特、舒柏特、柴
夫斯基…等古典大師著名作品。適度改編，難易
中，喜愛古典音樂琴友絕對不可錯過。

全系列4本
1000元
【免郵資】

樂享音樂趣

憑本書**劃撥單**購買任一書籍

可享 **9** 折優惠，滿千免運

另加贈**音樂飾品**1件
（數量有限，送完為止）

※套書優惠價恕不配合此9折優惠。
※公司保有活動變更之權利。

超級星光樂譜集（一）定價 380元

★ 收錄第一屆「超級星光大道」61首對戰歌曲中最經典、最膾炙人口的中文流行歌曲鋼琴套譜，讓您學習、彈唱一次擁有。
★ 「星光同學會」十強紀念專輯完整套譜。
★ 本書以鋼琴五線譜編著，另有吉他六線譜版本。
★ 每首歌曲均標註有完整歌詞、原曲速度與和弦名稱。善用音樂反覆記號編寫，每首歌曲翻頁降至最少。

因為我相信｜人質｜我愛的人｜離開我｜愛是懷疑｜無盡的愛｜背叛｜Forever Love｜記得｜腳踏車｜我們小時候｜不想讓你知道｜痛徹心扉｜離人｜領悟｜重返寂寞｜末日之戀｜到不了｜心動．心痛｜拔河｜今天你要嫁給我｜你那麼她｜梁山伯與茱麗葉｜屋頂｜是你決定我的傷心｜Superwoman｜Goodbye My Love｜雨天｜陌生人｜夜夜夜夜｜改變｜往日情｜聽說愛情回來過｜那些日子｜沙灘｜猜不透｜安靜｜半個月亮｜上弦月｜新不了情｜可惜不是你｜靠岸｜你是我的眼｜深海｜專屬天使｜故鄉普悠瑪｜讓每個人都心碎｜月亮惹的禍｜千年之戀｜旋木｜對的人｜愛情樹｜你把我灌醉｜我是一隻魚｜懸崖｜江南｜愛得正好｜留給你的窗｜蝸牛｜祝我生日快樂

超級星光樂譜集（二）定價 380元

★ 收錄第二屆「超級星光大道」61首最經典、最多人傳唱之中文流行曲。
★ 「你們是我的星光」十強紀念專輯完整套譜。
★ 鋼琴五線譜編著，另有吉他六線譜版本。
★ 每首歌曲均標註有完整歌詞、原曲速度與和弦名稱。善用音樂反覆記號編寫，每首歌曲翻頁降至最少。

你們是我的星光｜火柴天堂｜如果還有明天｜天空｜緩慢｜同手同腳｜流浪記｜我恨我愛你｜我該得到｜桂花巷｜戀人啊｜一無所有｜你是我胸口永遠的痛｜愛得比較深｜心痛的感覺｜他不愛我｜One Of Us｜那一夜你喝了酒｜流淚手心｜汽球｜My Way｜在水一方｜花若離枝｜不公平｜雙棲動物｜彩虹（紀曉君）｜彩虹（動力火車）｜女爵｜四百龍銀｜沒關係｜不了情｜卡門｜你不是我朋友｜藍天｜鼓聲若響｜我要我們在一起｜My Anata｜路口｜我給的愛｜I'm Alive｜夢醒了｜馬德里不思議｜愛中飛行｜請跟我來｜愛和承諾｜原點｜左右為難｜Endless Love｜死心眼｜Don't Know Why｜阿嬤的話｜追｜L-O-V-E｜Time To Say Goodbye｜Loving You｜You Light Up My Life｜Cappuccino｜Promise Me｜傻瓜｜愛情｜年紀大了點

超級星光樂譜集（三）定價 380元

★ 繼超級星光樂譜集（一）（二）後，再度收錄第三屆「超級星光大道」61首近10年中最經典、最多人傳唱之中文流行曲。
★ 鋼琴五線譜編著，另有吉他六線譜版本。
★ 每首歌曲均標註有完整歌詞、原曲速度與和弦名稱。善用音樂反覆記號編寫，每首歌曲翻頁降至最少。

100 種生活｜我愛你｜Piano｜放生｜歌手與模特兒｜荒唐｜我還是不懂｜散了吧｜如果不是因為妳｜愛如潮水｜甘願｜相遇太早｜孤單Tequila｜她的眼淚｜忘了時間的鐘｜讓｜寂寞的季節｜我多麼羨慕你｜Venus｜This is 風箏｜我不難過｜愛瘋了｜氧氣｜小茉莉｜輸了你贏了世界又如何｜從現在到現在｜酒矸倘賣嘸｜咕嘰咕嘰｜陰天｜Close To You｜You Give Love A Bad Name｜Save Me From Myself｜The Greatest Love Of All｜有你真好｜曖昧｜紅豆｜第五街的誘惑｜星光祭｜愛你等於愛自己｜落雨聲｜一斛梅｜了不起｜了不起｜假娃娃｜壞壞惹人愛｜她在睡前哭泣｜跟著感覺走｜When You Believe｜不管有多苦｜一支獨秀｜開到荼蘼｜每次都想呼喊你的名字｜Julia｜I'll Be There｜One Night In 北京｜It's Too Late｜嘿嘿！Taxi｜愛的路上我和你｜搖滾舞台

PIANO POWER PLAY SERIES ANIMATION

鋼琴★動畫館

【西洋動畫】

編著 / 朱怡潔

監製 / 潘尚文

封面設計 / 陳芃彣

美術設計 / 陳芃彣

電腦製譜 / 朱怡潔

譜面輸出 / 李國華

midi / 朱怡潔

音樂製作 / 陳韋達

文案 / 朱怡潔

發行 / 麥書國際文化事業有限公司

 Vision Quest Publishing International Co., Ltd

地址 / 10647 台北市羅斯福路三段325號4F-2

 4F.-2, No.325, Sec. 3, Roosevelt Rd.,

 Da'an Dist., Taipei City 106, Taiwan (R.O.C.)

電話 / 886-2-23636166，886-2-23659859

傳真 / 886-2-23627353

郵政劃撥 / 17694713

戶名 / 麥書國際文化事業有限公司

http://www.musicmusic.com.tw

E-mail:vision.quest@msa.hinet.net

民國108年4月 四版